IMAGES
of America

ROGERS

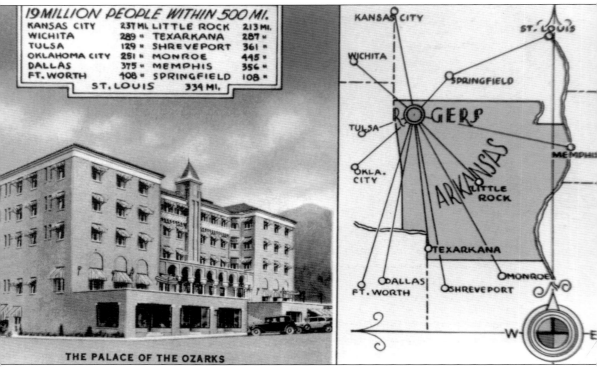

THE PALACE OF THE OZARKS

Rogers is within easy driving distance from major cities throughout the area. The original Lane Hotel was constructed in 1928 for a resort owned by Gus Lane. At the time of this picture, Earl Harris, a local baker, was the owner. Through the years, the hotel displayed various names by different owners to reflect its changing use—Hotel Arkansas, Defender's Townhouse, Rogers Townhouse, and Peachtree at the Lane. (Courtesy of the Rogers Historical Museum.)

ON THE COVER: Building facades in this mid-1920s scene of First Street in downtown Rogers are much the same today. Dedicated citizens along with the Rogers city government, Rogers Historical Museum, downtown business owners, and Main Street Rogers have preserved as much as possible the beautifully designed streetscapes throughout the city. (Courtesy of the Rogers Historical Museum.)

IMAGES
of America

ROGERS

Marilyn Harris Collins
The Rogers Historical Museum

ARCADIA
PUBLISHING

Published by Arcadia Publishing
Charleston SC, Chicago IL, Portsmouth NH, San Francisco CA

Printed in the United States of America

Library of Congress Catalog Card Number: 2006925669

For all general information contact Arcadia Publishing at:
Telephone 843-853-2070
Fax 843-853-0044
E-mail sales@arcadiapublishing.com
For customer service and orders:
Toll-Free 1-888-313-2665

Visit us on the Internet at www.arcadiapublishing.com

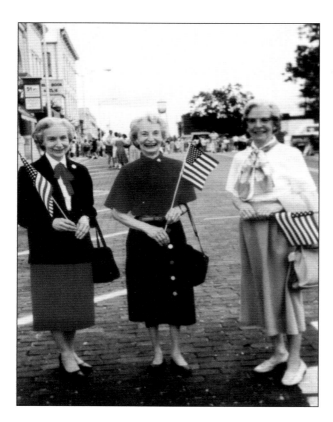

This book is dedicated to, from left to right, Betty Lynn Reagan, Mary Sue Reagan, and Agnes Lytton Reagan. Mary Sue and Betty Lynn were inspiring and beloved social studies teachers at Rogers High School. Through the years, the three sisters have given enthusiastic support to the community, schools, and historic preservation efforts. They are the great-great-granddaughters of early mill owner Peter Van Winkle. (Courtesy of the Rogers Historical Museum.)

CONTENTS

ACKNOWLEDGMENTS

This book celebrates the people who founded and nourished the city of Rogers from its inception in 1881 to today. I thank each person who helped make this project possible. My heartfelt gratitude especially goes to the staff and volunteers of the Rogers Historical Museum for their faithful stewardship in preserving the stories, pictures, artifacts, and—most of all—the spirit of Rogers for today and future generations.

Dr. Gaye Bland, museum director, has been incredibly helpful with her knowledge of the town's history. I relied greatly on her technical computer skills, which ensured the best pictures were used to tell this story of Rogers. Members of the museum staff and volunteers have helped locate pictures, acquire releases, provide fact-checking, and in general give support to this effort. Especially helpful were David Beard, Sarah Price, Terrilyn Wendling, Pat Campbell, Arva Goodwin, and Jeanette Walker.

One of the most rewarding aspects of working on this book was the opportunity to share with people their stories and pictures that together document our history. Among the contributors were Sam Wood, Jerry Hiett, Opal Beck, Jim Strong, Gary Townzen, and Shirley and Dean Park. The community is richer for their caring and diligence in keeping their photographic treasures safe for generations to come.

I am very grateful to Adam Ferrell of Arcadia Publishing for his positive support throughout this project and his faith in working with me on a third book based on local history.

My special thanks go to members of my family for their encouragement and expertise: Larry Collins, Shirley and Dean Park, and Barbara Youree.

—Marilyn Harris Collins

INTRODUCTION

Settlers began to arrive in the vicinity of what is today Rogers as early as 1830, and the town itself was founded in 1881. With 175 years filled with interesting people and events behind us, a book of this sort cannot and is not meant to be a complete history. And with thousands of images from which to choose, selecting only about 200 for inclusion was a daunting task for author Marilyn Collins.

Thus this pictorial history offers only a sampling of the most interesting photographs, selected to illustrate the highlights from our past. But if it whets your appetite for more, Marilyn's earlier book, *Rogers: The Town the Frisco Built*, offers a comprehensive history of our community.

The chapters within focus on some of the more important themes from Rogers history: the town's early years; the role of our well-preserved historic downtown in community life; the importance of agriculture in our past and our present; education and worship; community celebrations and family fun; and the ongoing efforts to preserve our past. The purpose of this introduction is to provide readers with a brief history of Rogers, placing those themes within a broader context.

When the first settlers arrived in Northwest Arkansas, they found plentiful stands of virgin timber, acres of lush prairie, and an abundant supply of water in the form of both springs and streams. The foundation of the local economy in those early years was subsistence farming.

There were among the early settlers a handful of lawyers, physicians, and businessmen. The many streams in the region provided power for grist and lumber mills, including the Blackburn family's mills at War Eagle. The plentiful timber allowed entrepreneur Peter Van Winkle to build a lumber empire east of what is today Rogers.

By the late 1850s, the area was progressing at such a pace that there was discussion of the need for rail transportation, but the Civil War devastated the economic development of the region. Area residents found themselves caught in the crossfire between Union and Confederate armies. They watched helplessly as their crops were confiscated and their barns, homes, and mills were destroyed.

The climax of the fighting came in March 1862, when what many historians consider the most important battle fought west of the Mississippi took place north of what would become Rogers. The Battle of Pea Ridge saved Missouri for the Union, but it did not end the suffering of area residents. Skirmishes continued, hunger was widespread, and guerillas and bushwhackers preyed on local families.

Residents devoted the 1870s to rebuilding. Key to that rebuilding was the arrival of rail transportation. In the 1870s, the St. Louis and San Francisco Railroad, better known as the Frisco, decided to follow a route through eastern Benton County, bypassing the county seat of Bentonville. The railroad established stations along the route, and around each of those depots a town grew. One of those towns was Rogers, which celebrates as its birthday May 10, 1881, the day the first Frisco train pulled into town to be greeted by a large and enthusiastic crowd.

In the late 1800s and early 1900s, Benton County was the leading apple-producing county in the nation. Situated along the rail line in the heart of "The Land of the Big Red Apple," Rogers

grew as a shipping point for apples and a trade center serving the surrounding countryside. Along the railroad tracks were produce houses, apple evaporators, and an enormous plant that produced apple cider vinegar.

Notable residents during the town's early years included William H. "Coin" Harvey, a well-known political figure who developed a resort at nearby Monte Ne. In 1908, a hometown girl, Betty Blake, married the vaudeville performer Will Rogers. As Will went on to become a motion-picture star and one of the nation's most beloved entertainers, Betty too became an admired public figure.

By the 1920s, Rogers had grown to over 3,000 residents. Each year from 1923 through 1927, the town hosted the Apple Blossom Festivals, elaborate events held to celebrate the apple industry. Thousands of people came to see the parade, tour the orchards in bloom, and watch the coronation of the Apple Blossom Queen.

Year after year, rain soaked the floats and the parade-goers. The festivals ended. Disease and insects began to wreak havoc in the orchards, and soon there was no longer a thriving apple industry to celebrate. Fortunately area farmers found a new source of income: poultry growing. Within a few years, Benton County became the leading broiler-producing county in the nation.

Population growth in Rogers slowed dramatically during the Great Depression, and all but one of the community's banks failed. The Works Progress Administration employed jobless residents on a number of projects, including the building of a lake named Lake Atalanta in honor of the wife of O. L. Gregory, owner of the land on which the lake was built. The Rogers Relief Association raised funds for the needy, and Will Rogers came to town to give a benefit performance at the Victory Theater to help the relief effort.

Late in 1940, Rogers's National Guard unit was mobilized to active duty in anticipation of the outbreak of World War II. After World War II began, other Rogers men and women joined the military. At home, the Red Cross made surgical bandages and knitted gloves, sweaters, and helmet liners for the troops. Schoolchildren participated in war bond drives, and Boy Scouts collected newspapers for recycling.

After World War II, agriculture remained important, but business leaders also embarked on an effort to recruit industry. A Munsingwear hosiery plant opened not long after the war's end. Other factories followed, and in 1958, Daisy Manufacturing, a maker of air guns, moved its entire operation to Rogers from Plymouth, Michigan. The poultry industry continued to expand.

The construction of Beaver Dam, begun in 1960, created a lake providing recreation for tourists and retirees and a source of both hydroelectric power and water. The enormous growth the area has experienced since would not have been possible without the water supply provided by Beaver Lake. In the 1980s and 1990s, Rogers became one of the fastest growing cities in Arkansas, and the Northwest Arkansas region became one of the fastest growing areas in the nation. It has been estimated that in 2006 as many as 1,000 people per month are moving into the Fayetteville-Springdale-Rogers-Bentonville metropolitan area, and by 2000, Rogers had almost 39,000 residents.

With growth come challenges, one of which is protecting the historic fabric of the community. The last chapter of this book is devoted to the people and organizations that are working hard to see that Rogers does not lose its past. One of those organizations is, of course, the Rogers Historical Museum. And one of those people is Marilyn Collins, the author of this pictorial history.

All of us connected with the museum are so very grateful to Marilyn for her dedication to preserving local history through her writing. Thanks to her, those interested in learning more about Rogers history now have two wonderful sources: her earlier book, *Rogers: The Town the Frisco Built*, and this new volume in the Images of America series.

—Gaye K. Bland, Ph.D.
Director, Rogers Historical Museum

One

EARLY YEARS

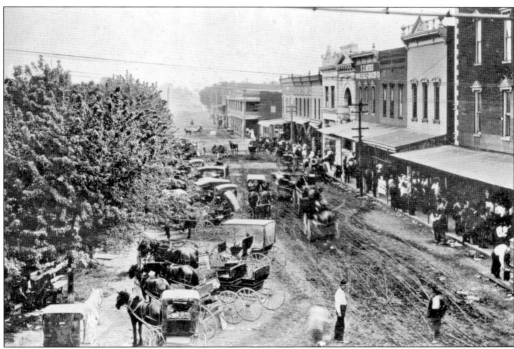

Horse-drawn carriages lined the dirt roads of First Street in Rogers, as shown in this c. 1916 picture. Rogers was a thriving center of business for the surrounding farms and nearby houses. One of the first businesses in Rogers sat atop a fallen tree on First Street, where the proprietor happily put up his saloon sign and enjoyed a thriving business. Early town ordinances decreed laws for both people and animals. Indecent songs or behavior was frowned upon, including loitering outside bawdy houses or associating with lewd persons. Animals could not be slaughtered or buried within the city limits. Farmers were not allowed to run large animals through the downtown streets. Playful youngsters were forbidden from swinging on boxcars or the engine as the train came through town unless they were bona fide passengers. (Courtesy of the Rogers Historical Museum.)

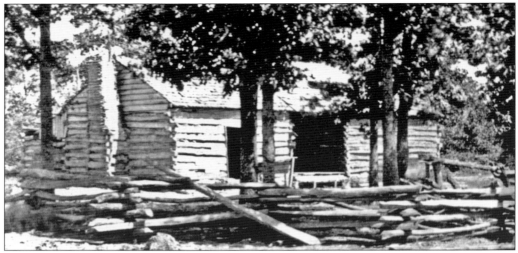

Robert and Elizabeth Sikes moved to the Rogers area from Tennessee in 1854. The Sikes cabin is a good example of early homes made from timber cut from nearby forests. Sikes's considerable land was later inherited by his children. Portions of this land were used as an economic incentive for the railroad to make the current town of Rogers a stop. (Courtesy of the Rogers Historical Museum.)

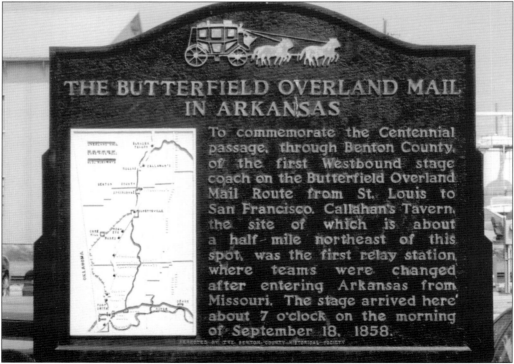

The Butterfield Overland Mail stagecoach line ran between St. Louis and San Francisco. Travelers endured a rough ride over crude trails with little or no comfortable accommodations along the way. The 2,795-mile trip took 25 days. The fare going west was $200 and $100 coming back, with day riders paying 10¢ a mile The stage stopped at Callahan's Tavern in Rogers, Elkhorn Tavern in Pea Ridge, and Fitzgerald's Station in Shiloh (Springdale). (Courtesy of Marilyn Collins.)

Rogers incorporated on June 6, 1881, but the true life of the town began earlier on May 10, when the St. Louis and San Francisco ("Frisco") Railroad came to town. The town was named in honor of Capt. Charles Warrington Rogers, general manager and vice president of the railroad. Along with his wife, Mary Shaw Rogers, he took great interest in the town and was instrumental in organizing the first church and school. (Courtesy of the Rogers Historical Museum.)

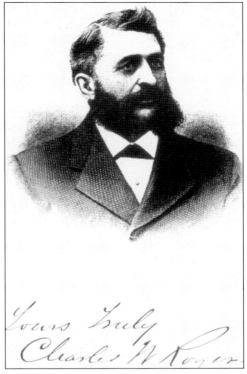

Land inherited by J. Wade Sikes, son of early settlers Robert and Elizabeth Sikes, along with land of his brother B. F. Sikes, constituted the first 50 blocks of the new town. Disagreement on how these early plats should lie resulted in the jog at Fourth and Cherry Streets that still exits. J. Wade Sikes served in the Civil War and was elected the first mayor of the town in 1881. (Courtesy of the Rogers Historical Museum.)

Sylvanus and Katherine Blackburn joined other people from Tennessee to settle in nearby War Eagle in 1832. Many families making the trek to the Ozark Mountains began in Tennessee, North Carolina, Kentucky, Virginia, Georgia, and Missouri. An abundance of water helped draw these settlers and power their sawmills and gristmills. Water also provided transportation that otherwise would have been more difficult over the rugged mountains of the area. (Courtesy of the Rogers Historical Museum.)

The son of early settlers to the area, J. A. C. Blackburn was instrumental in building the first water tower in town and organizing a water system in 1888. He served on the board of trustees of the Rogers Academy and became an Arkansas senator. He married Ellen Van Winkle, daughter of early mill owner Peter Van Winkle, and later took over operation of the mill. (Courtesy of the Rogers Historical Museum/Marilyn Hicks.)

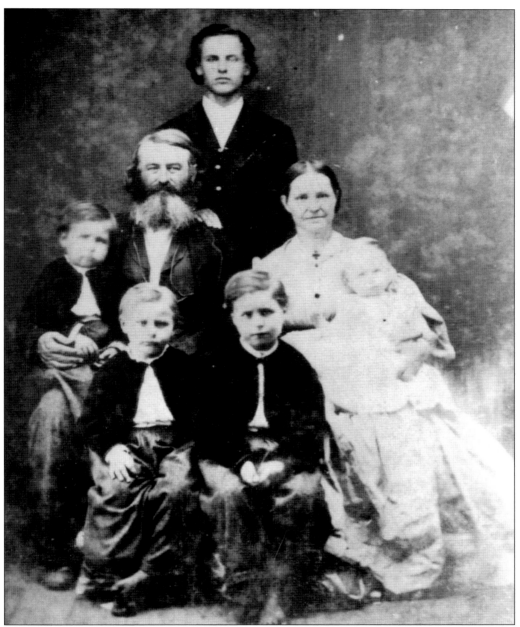

Early families depended on stump mills and, later, water-powered mills to grind their corn and grain. Lumber and furniture were also major products of the mills. Peter Van Winkle and his family (pictured here *c.* 1869) owned the largest lumber mill in this area. Mills were mostly wooden structures and would often burn or be washed away in spring floods. At one time, there were nearly 100 mills operating in Arkansas. Lumber from the Van Winkle mill was used in the construction of Old Main on the University of Arkansas campus in Fayetteville, Arkansas; the 1870s Benton County Courthouse in Bentonville, Arkansas; and many buildings in downtown Rogers. (Courtesy of the Rogers Historical Museum/Marilyn Hicks.)

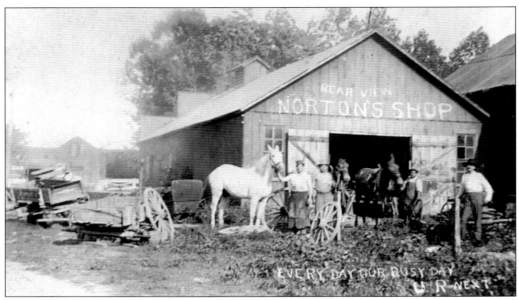

Businesses thrived on the growing local economy. Mule- and horse-drawn wagons hauled merchandise of the day, pulled the Butterfield Overland Stage across the mountains, and helped farmers do their work. Blacksmith shops were a familiar sight in the early days, as one of their jobs was shoeing horses and mules. "Every Day Our Busy Day" was an appropriate slogan for Norton's Blacksmith Shop in Rogers. (Courtesy of the Rogers Historical Museum.)

Fire was a major hazard to early downtown buildings mostly made of wood. The 1909 fire burned the Ozark Hotel along with most of the wooden downtown structures. The hotel was on the corner of Elm and Arkansas Streets and, at the time of this picture, was managed by Mr. and Mrs. Robert P. Pace, who are seated in the picture. They had sold their interests to B. J. Sikes just prior to the fire. (Courtesy of Jerry Hiett.)

William Henry Kruse was prone to visions. One led him to "see" gold under an old apple tree on his father's farm. He built a mine there in the early 1900s. The opening was celebrated with a parade led by the Rogers Cornet Band playing "In the Shade of an Old Apple Tree." Although only traces of gold were found, the mine continued in operation until Kruse died in 1926. (Courtesy of the Rogers Historical Museum.)

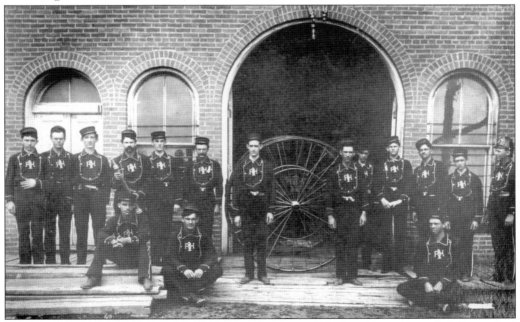

With all the wooden buildings of the time, a quick response to a fire alarm was needed. Rogers had a hand-pulled cart for many years. The town paid anyone who got to city hall first with a horse-drawn cart and helped put out the fire. This c. 1889 picture shows the hose cart in the background. It was not until 1915 that a motorized vehicle was used. (Courtesy of Gary Townzen.)

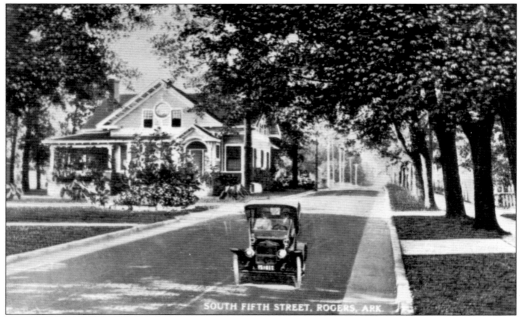

SOUTH FIFTH STREET, ROGERS, ARK.

Old-time residents still remember the lovely homes and tree-lined city streets leading into the downtown business district. This first scene gives a glimpse of the John E. Felker house *c.* 1890 on the corner of Cherry and Fifth Streets. The Felker house is one of the many homes and commercial buildings in Rogers designed by A. O. Clarke. Another look at this early grandeur is the A. L. Cadman House, built *c.* 1927–1929 at 624 West Walnut Street. Built in the Mediterranean style, this building is one of the few remaining structures of that design. The building, with few noticeable changes, is now commercially owned. (Courtesy of the Rogers Historical Museum.)

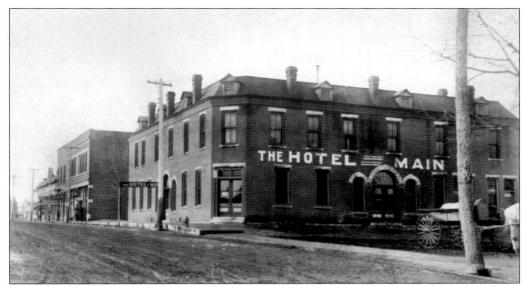

Early travelers often brought a tent for overnight stays in town. However, it wasn't long before three hotels were built in town—Jones Hotel, Nashburg Hotel, and the Hotel Main, pictured here *c.* 1910. Hotel Main was later the offices for the *Rogers Daily News*. Enterprising hoteliers were charged an annual fee of $12 to hawk rooms to the passengers coming off the train. (Courtesy of the Rogers Historical Museum.)

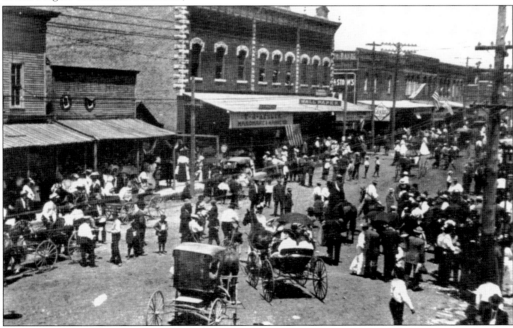

Hustle and bustle of market day is evident in this *c.* 1905 scene on Walnut Street. Brick buildings are beginning to replace the wooden ones seen at the left of the picture. City ordinances kept people and animals in order. Once such decree forbade carrying a bowie knife, sword, or spear in a cane . . . or pistols, with the exception of any military-issued pistol. (Courtesy of the Rogers Historical Museum.)

17

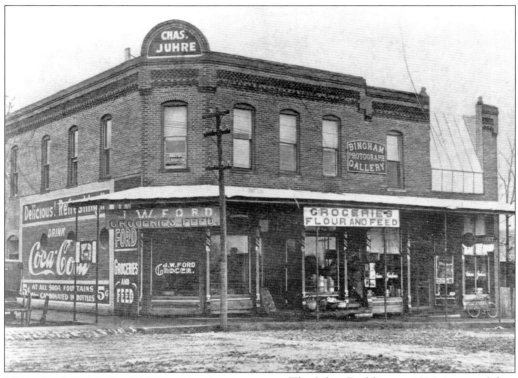

The Juhre Building, c. 1894, is one of the original downtown buildings that are listed on the National Register of Historic Places as part of the Walnut Street Historic District. Several businesses have occupied this space over the years, including the Rogers Grocery Company, Charles Juhre's meat market, and, in later years, Prized Possessions. Recently the Daisy Air Gun Museum moved from First Street to the Juhre Building. (Courtesy of Opal Beck.)

This grand home at 727 West Walnut Street belonged to Tom McNeil and family before the commercial development of the first Wal-Mart store and later Shelby Lane Mall behind where this house stood. Tom McNeil opened a Buick dealership in 1909 on Second and First Streets. (Courtesy of the Rogers Historical Museum.)

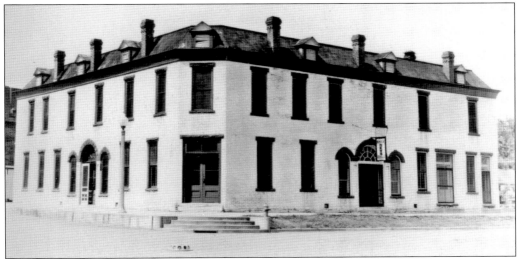

In 1881, D. W. Hinman owned *Rogers Champion*, Rogers's first newspaper. Unfortunately, politics led to its hasty demise. The newspaper editor customarily was also postmaster and was paid in accordance to the volume of mail he delivered to the train. Hinman was a Republican and not liked by the Democrats, who encouraged him to leave by posting their mail directly with the train, leaving the postmaster with little to do and few funds. In a line of subsequent newspapers, the *Rogers Daily News* housed in this building was the forerunner of the current *Morning News*. (Courtesy of the Rogers Historical Museum.)

Rogers New Era followed the demise of the *Rogers Champion* by about 10 days. The name was changed to the *Rogers Democrat* then the *Rogers Daily Democrat* in 1894. In 1919, Erwin Funk became editor of the *Rogers Democrat*, which, with the *Rogers Daily News*, combined mastheads and later became the *Morning News*. When criticized, his newspaper philosophy was: "Every editor must make his own decisions [about what to include in the paper]. . . . To me every issue of the *Democrat* was a personal letter to my readers." Funk posed for this picture while attending the National Editorial Association meeting in 1929. (Courtesy of the Rogers Historical Museum.)

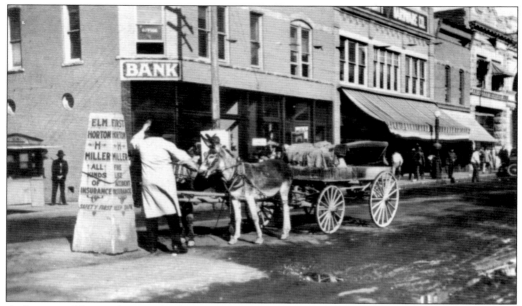

A driver and his mule get a little assistance on Walnut Street c. 1910. The advertising in the middle of the street certainly grabbed the attention of pedestrians and perhaps spooked some of the animals. Markers similar to this were used by the Ozark Trail Association organized by "Coin" Harvey. (Courtesy of the Rogers Historical Museum/Duane Hand.)

This Eastlake design home with distinctive ornamental details was photographed in 1905. It belonged to John Simon McLeod and was at 714 South Third Street. Mrs. McLeod belonged to the Mas Luz Reading Club, which helped to organize the first Rogers library in 1904. (Courtesy of the Rogers Historical Museum.)

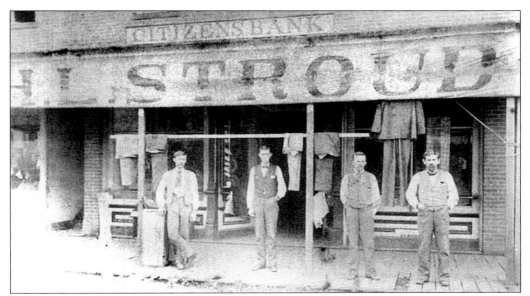

Stroud's Mercantile, one of the most successful downtown businesses, was first located on First Street, then 105 West Walnut, and finally 114–116 West Walnut Street in 1898. Goods were often hooked to racks over the sidewalk or displayed along the side of the street. Pictured here are early employees John Simon Sager (far left) and Carl Sager (far right). John Simon Sager married Allie Inez Dodge, the first female employee of the store and first businesswoman in Rogers. (Courtesy of Shirley and Dean Park.)

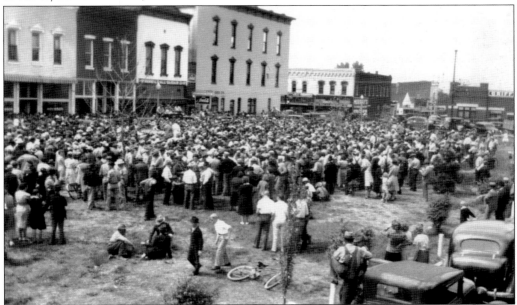

Sam Wood, photographer, did a great service to the town and to historic preservation through the many pictures he took during the 1930s and 1940s. His extensive collection (many included in this book) documents the everyday lives of local people and the effects of a changing world both at home and around the world during this period. There is little difference in this scene and the one from 1910 with the exception of cars. (Courtesy of Sam Wood.)

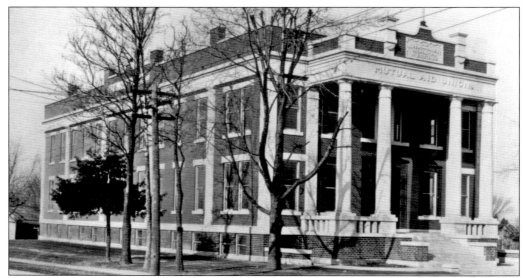

Originally named the Mutual Aid Building, this imposing structure built in 1913 at 224 South Second Street (corner of Second and Poplar Streets) has also gone under the name Progressive Life Building and Poplar Plaza. The portico and flat limestone lintels are trademarks of architect A. O. Clarke's design style. Beautiful wood appointments add elegance to the entry foyer of the building now owned by Keith, Miller, Butler, and Webb law firm. The lower level has often been used as a restaurant and is currently occupied by La Fiesta restaurant. The Congregational Church was the first building on this downtown corner. (Courtesy of the Rogers Historical Museum.)

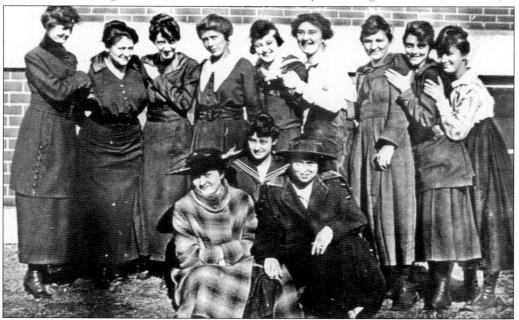

Taking group pictures of the women who worked in the Mutual Aid Building seemed to be an annual tradition. Referred to as the "Mutual Aid Girls," they were often dressed similarly, as they are in this 1918 picture—sailor-suit collars on their dresses worn with high-top, buttoned shoes. (Courtesy of the Rogers Historical Museum.)

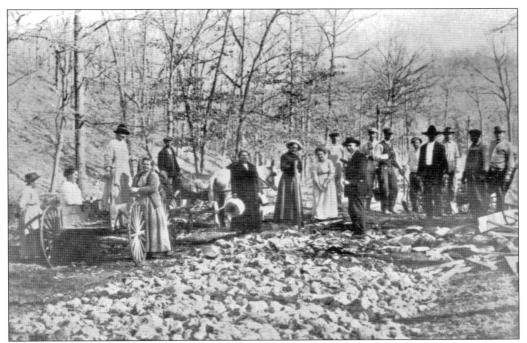

People in Benton County have always been public spirited and enterprising. In 1914, a large portion of the main road between Prairie Creek and the White River washed out in a major storm. Since the county had no money to make road repairs, local people took it upon themselves to put the road back in serviceable condition so that people living in the Electric Springs area would not be isolated. (Courtesy of the Rogers Historical Museum/Vera Key estate.)

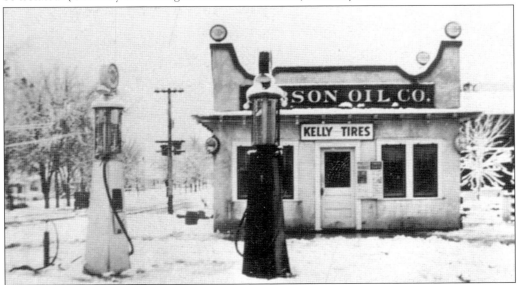

In 1903, W. H. McMullin owned the first car in town. Seeing the growing use of cars, Tom McNeil opened a Buick dealership on Second and Poplar Streets. Service stations like the Gibson Oil filling station on Fourth and Walnut Streets in Rogers became a necessity of the times. (Courtesy of the Rogers Historical Museum.)

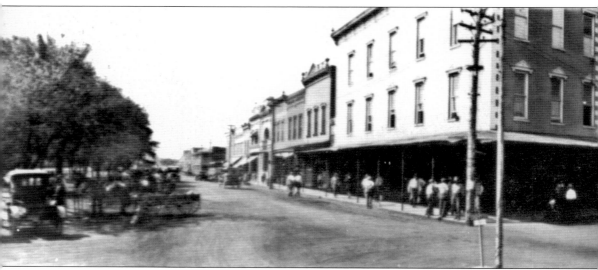

This unusual view down First Street on the left and Walnut Street on the right gives the photographer's overall view of the downtown buildings and the park along the railroad tracks

Long after their voices were silent, actors and actresses left their mark for history on the inside walls of the Opera House housed in the Opera Block building on the corner of First and Walnut Streets. Names of performers, the play titles, and show dates are scrawled across the interior walls. Stadium-style seating, stage, ticket window, and signature walls still exist today above the Townzen Barber Shop and Dixieland Shoes. (Courtesy of Clifton Eoff.)

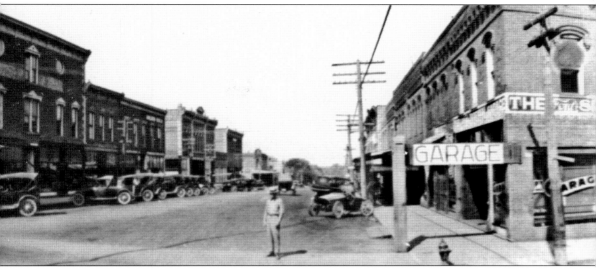

facing the First Street businesses. (Courtesy of the Rogers Historical Museum.)

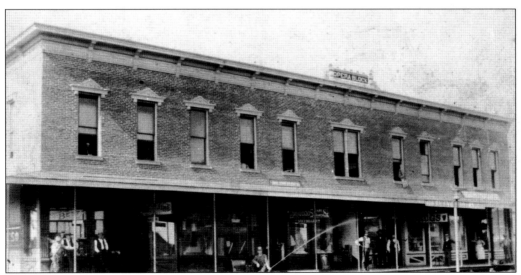

The Opera House—featuring local dances, touring Chautauqua shows, traveling vaudeville drama groups, political rallies, and large social functions—was the center of entertainment in the late 1800s. The Opera House was owned by local businessman W. A. Miller. In 1897, the first moving picture show in Rogers was shown at the Opera House. (Courtesy of the Rogers Historical Museum.)

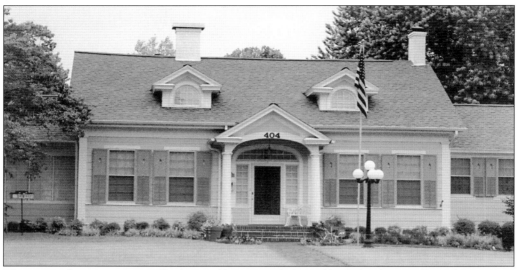

This *c.* 1920 house was originally designed by A. O. Clarke and built for Elmo Walker. The attorney Claude Duty and his family lived there for many years. The symmetrical balance of windows and dormers are typical of a neoclassic Cape design. (Courtesy of Marilyn Collins.)

In 1981, the Benton County Bar Association honored the oldest attorneys in the county. Receiving recognition were, from left to right, Russell Elrod, Floyd Rees, Jeff Duty, and Wesley Sampier. (Courtesy of the Rogers Historical Museum/Duty family.)

Two
HISTORIC DOWNTOWN

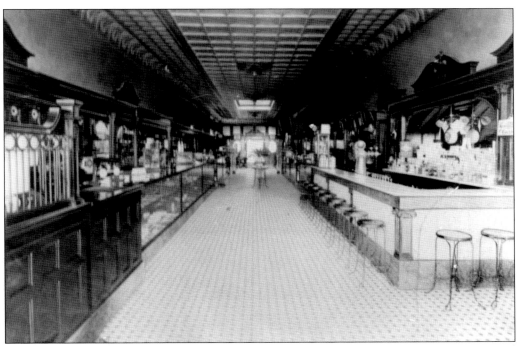

Brothers J. E. and A. R. Applegate opened their first drugstore on First Street where Centennial Park is today. J. E. bought his brother's shares in 1882 and went on to build his own structure farther south on First Street. The building was beautifully designed by A. O. Clarke of the firm Matthew and Clarke of St. Louis and is listed on the National Register of Historic Places. The interior is elegantly appointed with inlaid tile floors, marble counter tops, pressed tin ceilings, and mahogany counters and shelves. Original ceramic knobs are still in place on the drawers. Townspeople well remember the ice cream parlor in front of the store. Betty and Steve Goodman later opened Poor Richard's Gift and Confectionery, a thriving business on the same site for many years. (Courtesy of the Rogers Historical Museum/John Applegate.)

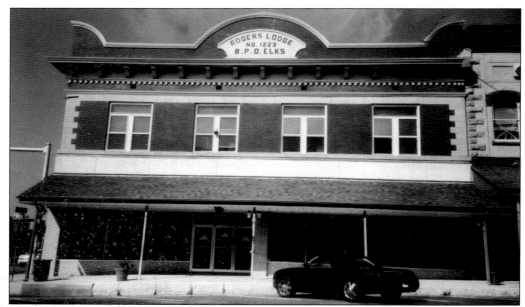

Another A. O. Clarke design is the c. 1909 Elks Lodge building on Second and Walnut Streets. Benchmark Group currently owns the building and has restored the sign "Rogers Lodge No. 1223 B. P. O. Elks." The building is listed on the National Register of Historic Places. A number of other civic organizations were prominent in the late 1800s and early 1900s, including the International Order of Odd Fellows (1883), Masonic Lodge (1887), and the YMCA (1907). (Courtesy of Marilyn Collins.)

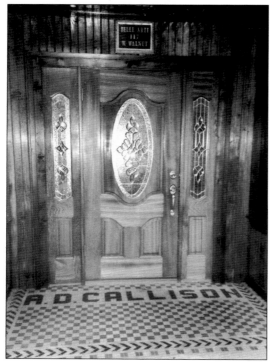

For many years, families in Benton County relied on Burns Funeral Home and Callison Funeral Home for compassionate service. A. D. Callison was a partner in the Callison-Porter Funeral Home. His business was first at 117 West Walnut, where the tile entrance to the building shown above now leads patrons into the Belle Arti restaurant. Callison's has been located at 408 West Walnut Street for many years and is currently under the name Callison-Lough Funeral Service. (Courtesy of Marilyn Collins.)

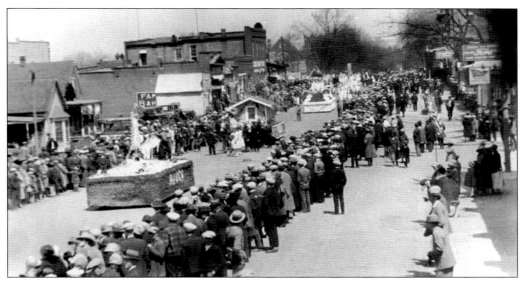

In the 1920s, over 35,000 people clogged the streets of Rogers to help celebrate the annual Apple Blossom Festival. Benton County led the nation in apple production, so there were plenty of reasons to celebrate with beautiful girls in gossamer gowns riding floats colorfully decorated with crepe-paper apple blossoms. The parades ended in 1927 when the apple industry fell on hard times because of uncontrollable insects and diseases. (Courtesy of the Rogers Historical Museum.)

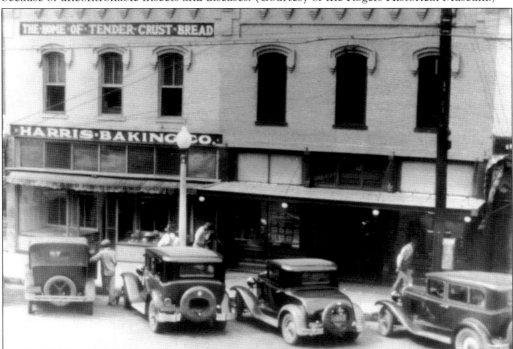

Harris Baking Company (HBC) bread was part of many sandwiches made in homes throughout Rogers. Established in 1936, the company continues today on South First Street selling under private labels. In the 1930s, Earl Harris owned the bakery as well as the Harris Hotel. (Courtesy of the Rogers Historical Museum.)

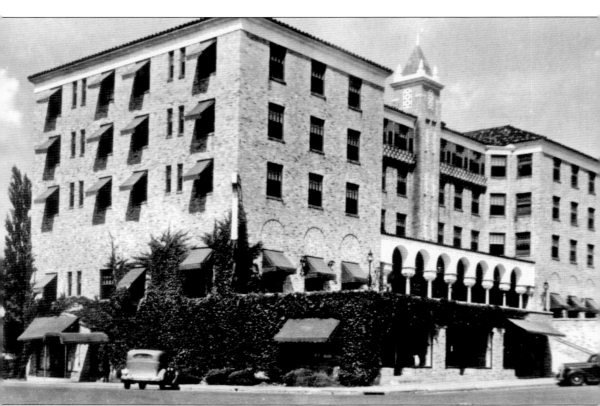

This magnificent resort hotel was designed by John Parks Almand for Gus Lane in 1928 to meet the needs of tourists and businesspeople drawn to the sparkling waters and beautiful mountains of the Ozarks. The Lane Hotel is made of steel and brick and was known as the first fireproof building in Arkansas. A wide expanse of foot-wide steps lead up to the 50,000-square-foot building. Entering the foyer, a visitor is struck by the overhead carved mahogany beams and large fireplace with a carved screen depiction of St. George slaying the dragon. The red-tiled roof completes the Moorish and Spanish architectural style. Townspeople remember limousines stopping at the hotel when famous people such as Amelia Earhart, Jack Dempsey, and Will Rogers mixed with other tourists to enjoy the area. (Courtesy of the Rogers Historical Museum.)

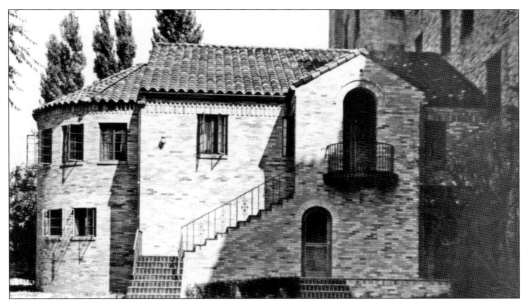

Many will remember eating at round, wooden tables in the elegant Orchard Room (top image), built as an addition to the hotel in 1938. The outside staircase led to the landscaped gardens below. The structure has been both a resort hotel and a retirement home according to the various owners, successively carrying the name of Lane, Harris, Hotel Arkansas, Defender's Townhouse, Rogers Townhouse, and Peachtree at the Lane. A sales meeting takes place in the ballroom next to the foyer in the bottom image. Note that the chandeliers in this room are cleverly designed to do double service as fans. (Courtesy of the Rogers Historical Museum.)

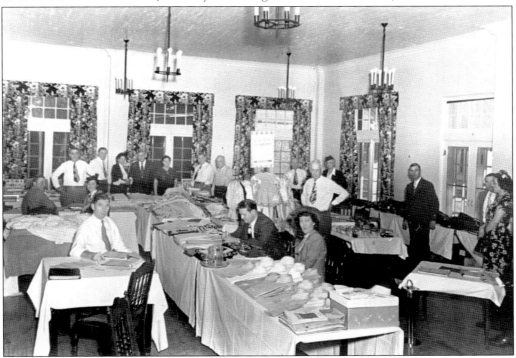

One of the original businesses established in 1928 that has withstood the test of time is the Model Laundry on the corner of Elm and Third Streets across from the old city hall. Except for the added awnings, the building looks much the same today as it did in the mid-1900s. (Courtesy of the Rogers Historical Museum.)

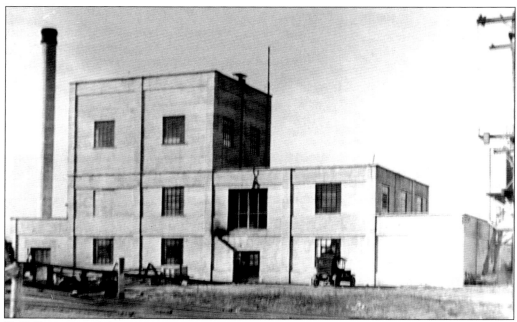

H. Y. King opened the Rogers Ice and Cold Storage plant in the early 1890s. The plant, on South Arkansas Street, shown here c. 1927, delivered large blocks of ice to residential customers. Cold storage was also important to the produce business, keeping locally grown fruit fresh for market. The plant could produce 20 tons of ice a day and handle 100 cars of apples at a time. (Courtesy of the Rogers Historical Museum.)

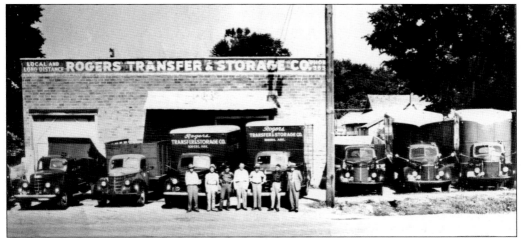

William Kennan started the Rogers Transfer and Storage Company in 1902. The company was originally in business to transport produce in horse-drawn wagons. Later, with the change to motor vehicles, the company also moved household goods and commercial items. In 1948, this family-owned business became an agent for North American Van Lines. (Courtesy of the Rogers Historical Museum/David Kennan.)

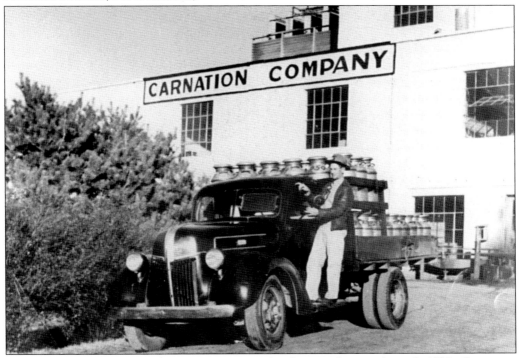

Fruit, the cash crop for several years, gave way to other farm products in the early 1930s. Carnation Milk was among the upcoming businesses depending on area farmers. The company began operation in Rogers in 1935. Farmers milked their cows, strained the milk into large metal cans, and set them beside the road for pickup by Carnation trucks for processing. Carnation trucks not only picked up milk, but also provided schoolchildren a ride into town. (Courtesy of the Rogers Historical Museum/Paula Smith.)

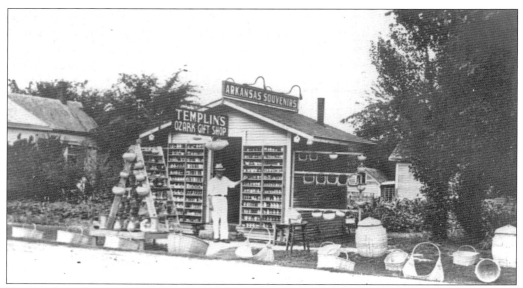

Tourism brought customers for some of the earliest businesses in Rogers. Templin's Ozark Gift Shop, advertising "Arkansas Souvenirs," exhibited their wares along Walnut Street in front of their shop. Baskets and canned goods seem to fill the outside display space. (Courtesy of the Rogers Historical Museum.)

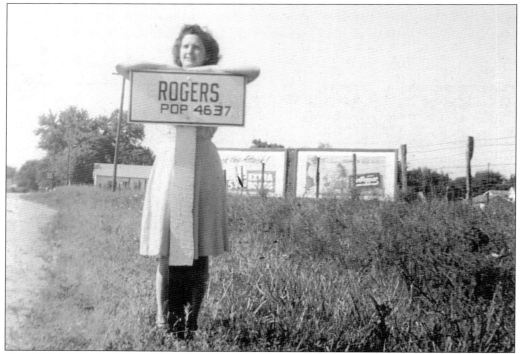

Gaynelle Woods stands by a sign leading into Rogers in the mid-1940s indicating the population at 4,637. By 1970, the population grew to 11,050; by 1990, it stood at 24,367 and rapidly increased to 38,829 by the census of 2000. The population was estimated to be 44,885 in 2004—and still growing. (Courtesy of Sam Wood.)

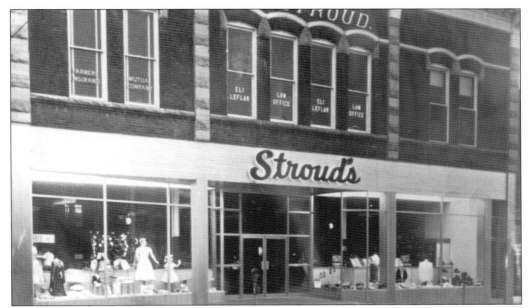

H. L. Stroud Mercantile, owned by brothers H. L. and A. B. Stroud, was one of the most prominent businesses in downtown Rogers. This evening picture of Stroud's was taken after the business moved to West Walnut Street. A. B. came into the business at the age of 14 and became manager by age 17. He introduced innovative ideas including hiring the first female employee (Allie Inez Dodge), banned smoking on the premises, and paid his bills the day they were received. (Courtesy of the Rogers Historical Museum.)

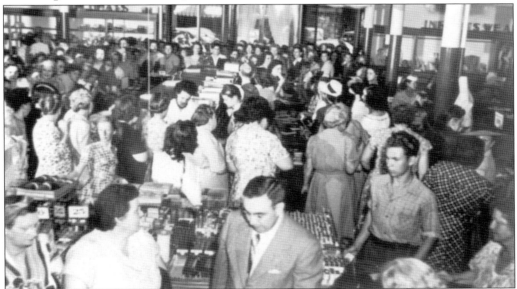

Stroud's was a busy place, as seen in the scene from the mid-1940s. Shoppers sought out individual clerks specializing in various items such as shoes, hats, suits, or dresses. Many people remember the clerks making change by sending the money through a suction system (similar to what drive-in banks use today), which carried the money upstairs for change and returned to the clerk and customer below. (Courtesy of the Rogers Historical Museum/Betty Crum.)

A success, Stroud's even stayed solvent during the Depression, when management contacted the principal of Rogers High School, Birch Kirksey, for an enterprising young man to help run the store. Kirksey recommended Harold Wardlaw, a high school senior. He became part owner in 1949—along with silent partners Lawrence, Gene, and Ray Harris. Ownership later changed to Wardlaw, H. K. Scott, and Bill Crum. Stroud's stayed in business for 109 years, finally closing in 1993. (Courtesy of the Rogers Historical Museum.)

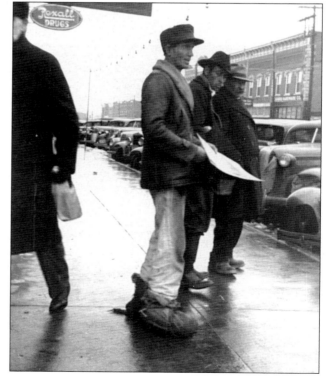

Tracy Lockhart was a one-person entrepreneur and familiar figure in downtown Rogers during the 1940s and 1950s. He met moviegoers leaving the Victory Theater or window shoppers with his familiar call, "Chewing gum, candy, right here handy." Lockhart first carried his wares in a basket, but later Beaulieu Hardware supplied him with a wheelbarrow. During cold weather, Lockhart wrapped his feet in burlap bags to keep them warm. (Courtesy of Sam Wood.)

Gary Ray Townzen, pictured in the center above, followed the footsteps of his grandfather Arthur Ray (left) and father Hershel Ray (right) as owner of the Townzen Barber Shop now on First Street in Rogers. Anyone interested in an enthusiastic story about Rogers can enjoy the lively discussion in this relaxed shop. To preserve Rogers's history and to help support the charity Feed the Children, Gary produces an annual calendar featuring historic pictures of Rogers. (Courtesy of Gary Townzen.)

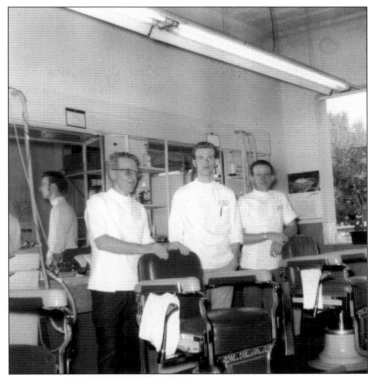

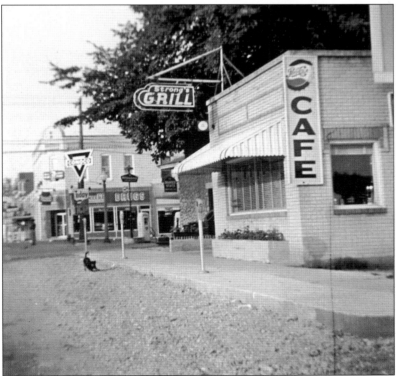

Strong's Grill, near the corner of Walnut and Second Streets, was a favorite stop for a reasonable meal. Customers in the early 1950s recall ordering a lunch of a toasted bread-lettuce-and-tomato sandwich for 15¢, with potato chips and a carton of milk for 5¢ each. A Conoco station stood on the corner, and across Walnut Street was the Rexall Drug Store. Arvest Bank is now on the site of Strong's Grill. (Courtesy of Jim Strong.)

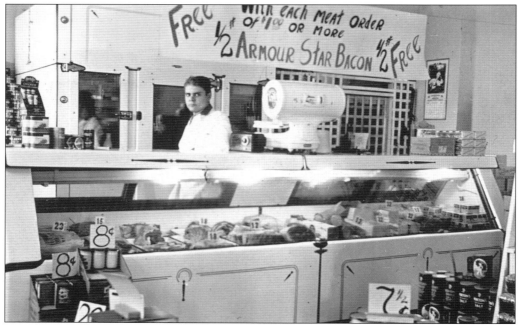

Grey's Grocery, a 1940s market, offered an attractive assortment of meat. The special discount for the day indicates one half pound of Armour Star Bacon with the purchase of $1 or more in other merchandise. Dean Bull stands behind the counter ready to help the next customer. (Courtesy of Sam Wood.)

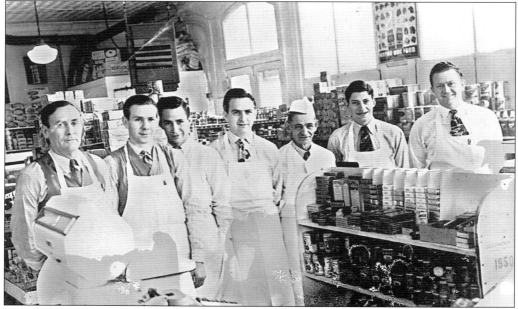

In the 1950s, Phillips and Sons Grocery occupied the corner of First and Elm Streets. Pictured from left to right are Marvin Phillips, Doell Phillips, Kenneth Phillips, Harlon Phillips, Butch Hawkins, Bill Price, and Doyle Phillips. Scales for weighing produce are in the foreground. Customers were sure to be helped by this large and friendly staff. (Courtesy of Kennita Rakes.)

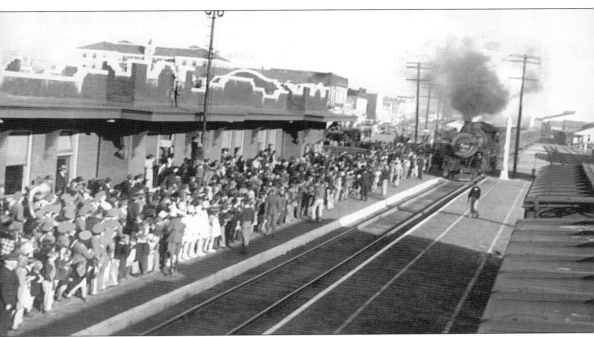

The Frisco Depot has been the center of energy since the first train came through on May 10, 1881. The nearby ice plant provided the means for cooling, which made it convenient for farmers to ship their fruit. Later the poultry industry took economic dominance, and chickens were shipped by rail. Watching the train come in or leave was a treat for many families during the early years of Rogers. Imagine the excitement of children—and adults—who lined up for the Frisco train to come bringing Santa Claus to town in the late 1930s. Barbara (Harris) Youree remembers her father holding her on his shoulders as the train pulled in to town. The band played and the people cheered as Santa arrived in this unusual way. (Courtesy of Sam Wood.)

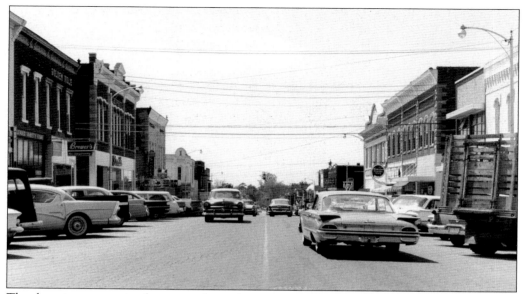

The changing streetscape downtown shows the continuing hustle and bustle of cars and prospering businesses. Brick streets laid in the early 1900s are evident in this scene, as they are today. Building facades have also remained much the same through the years, due in part to the preservation efforts of the merchants and Main Street Rogers. Fortunately the architectural design has not been covered with siding as in so many forgotten downtowns. (Courtesy of Jerry Hiett.)

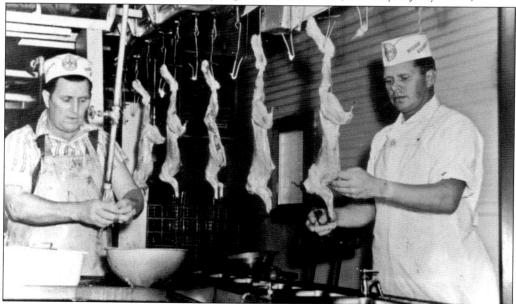

New national businesses began locating in Rogers, including Munsingwear (1947), Wendt-Sonis Company (1953), Emerson Electric (1965), Preformed Line Products (1969), Swift Chemical (1975), Glad Home and Automotive Products and Union Carbide (1971), Hudson Foods (1972), and Scott Paper (1973). H. F. Pelphrey and Son opened Pel-Freeze Biologicals, Inc., and Pel-Freeze Fur (1951). Workers are shown working in the Pel-Freeze Rabbit Meat branch of the company. (Courtesy of the Rogers Historical Museum.)

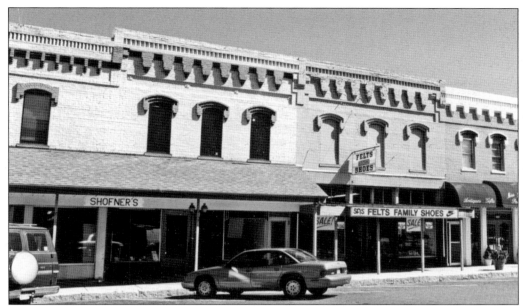

Since 1888, Shofner's Office Supply and Felts Family Shoes were family-owned, longtime business neighbors on Walnut Street in downtown Rogers. Both buildings are part of the Walnut Street Historic District and are listed on the National Register of Historic Places. (Courtesy of Marilyn Collins.)

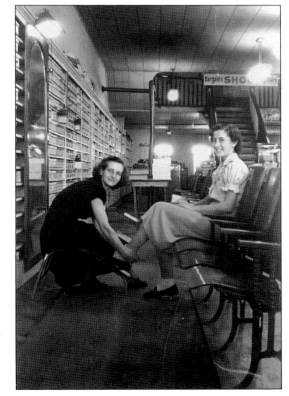

Store manager Aileen Adams was a familiar face in Felts Family Shoes for many years. Here she shows a pair of shoes to Shirley (Harris) Park, who also worked in the store during the 1950s while in high school. When the store was sold in early 2004, nostalgia drove old-time customers to buy one last pair of shoes. (Courtesy of Shirley Park.)

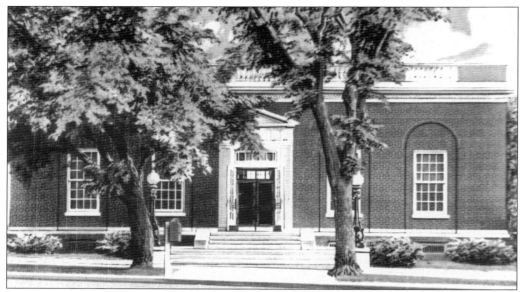

In the early days, "postmaster" was a political position with volatile tenure. Between 1881 and 1902, for instance, there were eight postmasters in Rogers. Finally a permanent post office was built on the corner of Second and Poplar Streets in 1919. In 1961, the Hough-Kimble Foundation, under the leadership of Cass Hough of Daisy Manufacturing, donated $100,000 to help open the public library in that building. The site is currently used by the Rogers Historical Museum for educational programs. (Courtesy of the Rogers Historical Museum.)

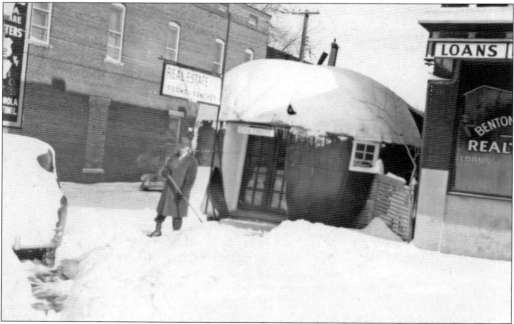

Jim Tucker, "The Land Man," conducted his real-estate business from a building shaped like a large red apple. In this picture on Walnut Street, the apple is snow-capped, but customers will soon have a path shoveled to the front door. (Courtesy of Sam Wood.)

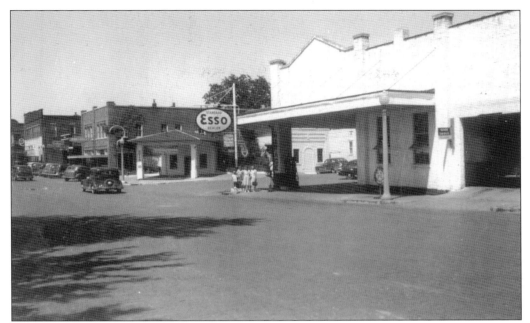

Bus travel was a common means of transportation in the 1940s. The author remembers as a child going to the Greyhound Bus Station on Second Street to pick up her father, who sometimes did electrical work outside the area. There was something exciting about the bus coming in from far-off places, then pulling back on the open road. (Courtesy of the Rogers Historical Museum.)

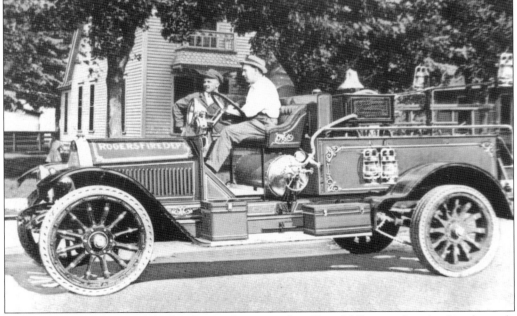

This 1910 Rogers fire truck had a chemical engine when Finis Miller was fire chief in the early 1900s. Twenty-three men have held the job as fire chief. Cited for longevity are Dr. George M. Love (1922–1953), Frank Jacobs (1953–1966, acting chief 1950–1953), Richard Graves (1966–1976), and Kenneth Riley (1982–1999). (Courtesy of the Rogers Historical Museum.)

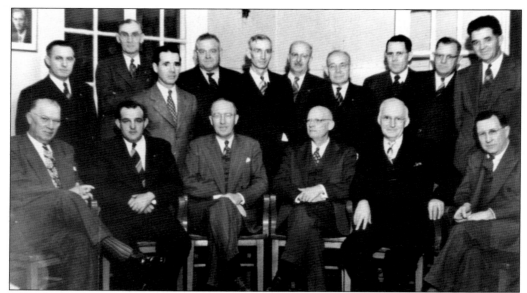

There has always been an active interest in business in Rogers, starting with the first board of trade in 1903 led by J. W. Walker, president. E. M. Funk was president of the Rogers Commercial Club in 1907, which was followed by the Rogers Rotary Club in 1917. Next came the Rogers Community Club led by Vint Deason until the Rogers Chamber of Commerce formed in 1942. Shown above are the first members of the Rogers Chamber of Commerce. (Courtesy of the Rogers Historical Museum.)

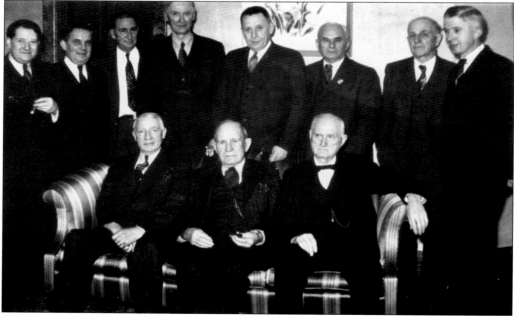

On January 30, 1941, physicians in the area took time to celebrate Dr. Curry's 90th birthday: from left to right are (seated) Dr. Bill Mock, Dr. W. J. Curry, and Dr. E. F. Ellis; (standing) Dr. Clyde McNeill, Dr. W. R. Brooksher, Dr. L. O. Greene, Dr. A. J. Harrison, Dr. Guy Hodges, Dr. George M. Love, Dr. W. A. Moore, and Dr. Everett Moulton. (Courtesy of the Rogers Historical Museum.)

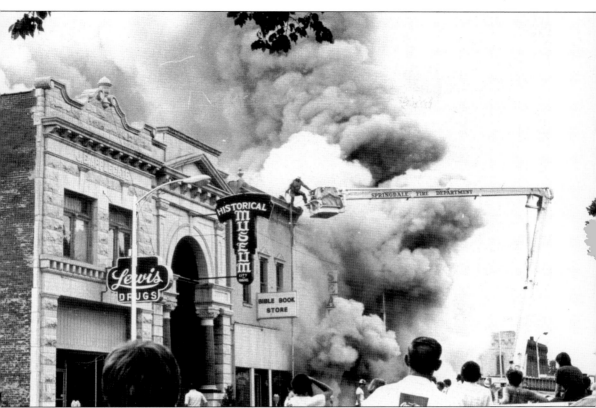

A tar pot left smoldering in the alley behind First Street buildings exploded, and the fire destroyed the House of Fabrics and the Sears store where Centennial Park is today. The fire placed other buildings on the street in peril, including the Rogers Historical Museum and Townzen Barber Shop. Museum volunteers quickly began removing artifacts from the museum, but fortunately smoke damage was the worst effect for the museum. (Courtesy of Gary Townzen.)

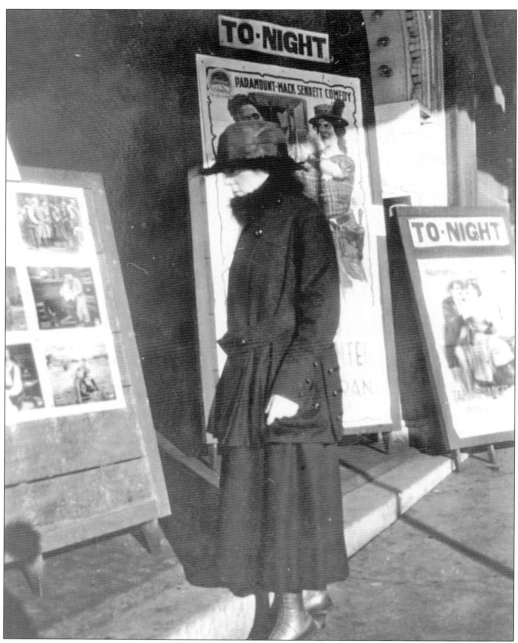

Lillian McLeod pauses to look for upcoming events posted on the sandwich boards outside the Victory Theater at 114–118 South Second Street. The *c.* 1927 Victory Theater is another A. O. Clarke design detailing neo-Spanish and Mission architectural details. Heavy red, velvet curtains covered the walls inside, separated by Corinthian-style capitals. The first talking movie was shown in 1929. The building has had several uses but is now owned by the Rogers Little Theater, which currently hosts musicals and dinner theater performances on a regular basis. With hard work and generous community support, the organization restored the building to its former grandeur. (Courtesy of the Rogers Historical Museum.)

The 1895 Hawkins House is on the corner of Second and Cherry Streets. The curved brick gable is a handsome detail on this Eastlake design home. In 1980, the Harold Hawkins family partially donated the home to the City of Rogers for use by the Rogers Historical Museum. The museum moved into this space in 1982. (Courtesy of the Rogers Historical Museum.)

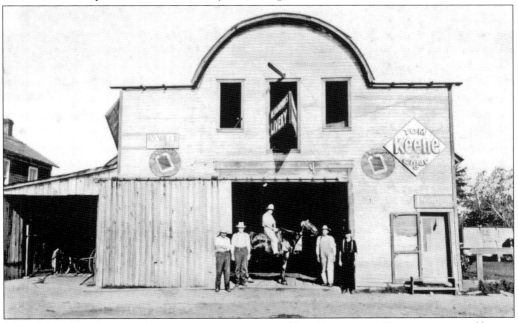

The McSpadden Livery stable was an important part of local business, offering wagons and horses for hire. Horses could also be stabled there. J. C. McSpadden was fire chief from 1905 to 1906, and T. C. McSpadden was city marshal in 1921. (Courtesy of the Rogers Historical Museum.)

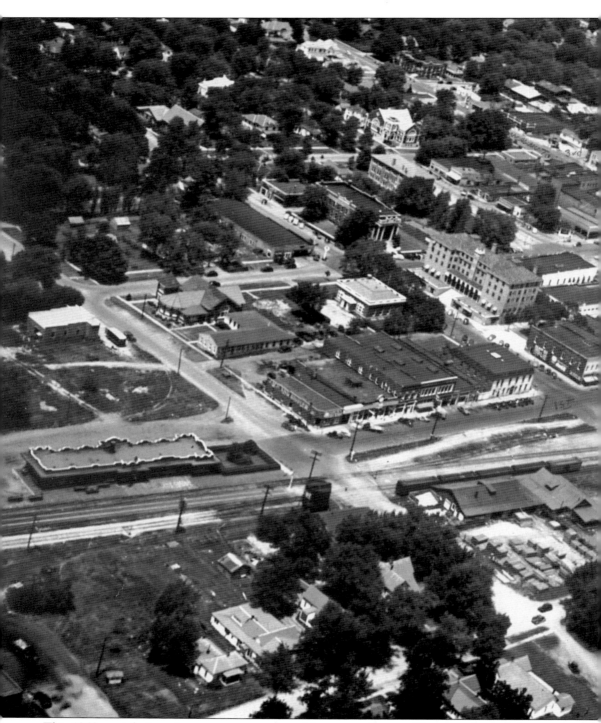

This 1960s aerial view gives some perspective of downtown Rogers. The view shows Arkansas Street and the railroad tracks; First Street with the Frisco Depot, water tower, Vinson Square, and other businesses; and the First Baptist Church, post office, Poplar Plaza, and Defender's

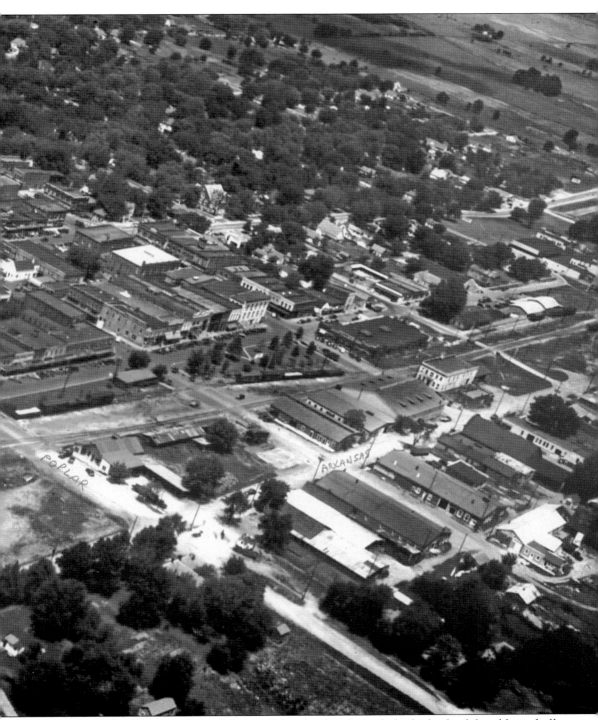

Townhouse bordering on Second Street. Other landmarks include the back of the old city hall building, Central Methodist Church, and Rogers High School in the far distance. (Courtesy of Gary Townzen/City of Rogers.)

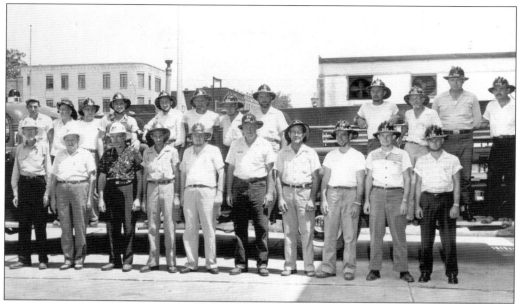

Men of the Rogers Fire Department in 1956 were, from left to right, (first row) Chief Frank Jacobs, Bill Keltner, Jack Allumbaugh, Homer Sweeten, Earl Reddick, Guy Carter, W. B. "Junior" Kennon, Rudy Atchison, Dale Bland, and Rex Watkins; (second row) Lloyd Kiper, Fate Miller, Pat Roughton, George Price, Dr. ? Jackson, Bob Brown, Richard Daylong, Henry Welborn, Richard Graves, F. D. Sheedlin, Leon Clinton (state trooper), and Charlie Gundlach; not shown are Jim Shofner, Jasper Clawson, Roy Pickett, and Fred Winchester. (Courtesy of Gary Townzen.)

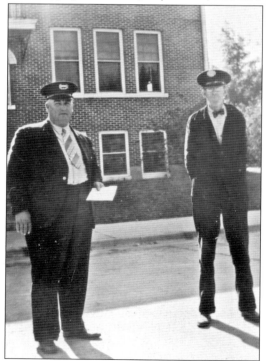

Walter C. Dean was the first Rogers chief of police and served from 1944 to 1953. The police department was housed at that time in city hall on Elm Street. Dean (left) is pictured here with Frank Jacobs, fire chief from 1953 to 1966. (Courtesy of Sam Wood.)

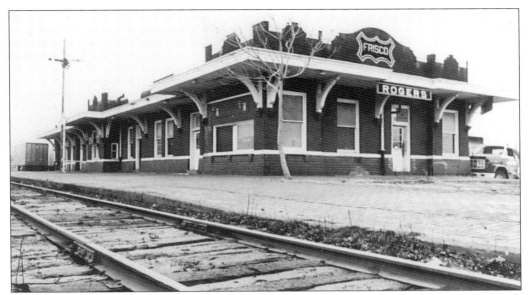

Frisco Depot was a much-loved landmark in town and often a place of entertainment. After church on Sunday night, the author's family used to drive over and park next to the tracks to watch the train come in. If you stared hard enough at the moving train, the train seemed to stand still and you were the one moving. Although the building was listed on the National Register of Historic Places, the depot was torn down (pictured below) in 1977, much to the dismay of townspeople. Main Street's Frisco Festival, held each year, continues to celebrate the glory days of the Frisco train. (Courtesy of the Rogers Historical Museum/Benton County Historical Society.)

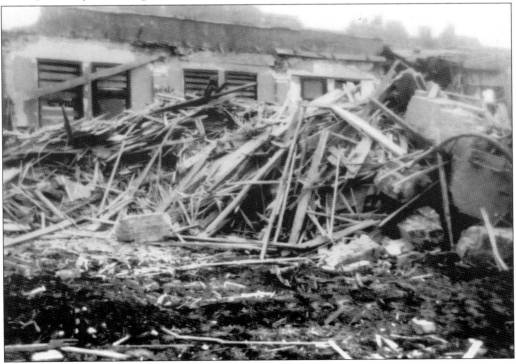

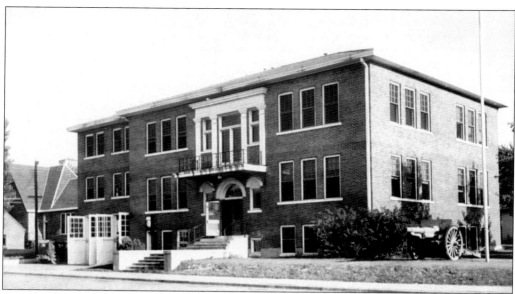

Rogers City Hall on Elm and Third Streets was designed by A. O. Clarke and dedicated in 1929. The c. 1910 cannon was given to the city in the 1930s. Children used to play on the cannon and mischievously wrote their names there for posterity. A granite memorial was later placed beside the cannon and dedicated to all armed forces. The building has served as the public library and various town offices through the years. (Courtesy of the Rogers Historical Museum.)

George's Flowers on Walnut and Fifth Streets has been in business since 1966, offering floral arrangements for celebrations and times of sadness of local residents for over 40 years. Randy Jones has been the owner for the past 15 years. Little has changed in the facade and structure. (Courtesy of Marilyn Collins.)

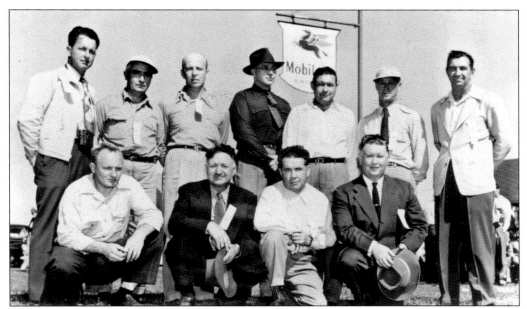

The Rogers Municipal Airport/Carter Field is a major contributor to the business growth in Benton County. Earl Harris was the first Airport Association president, followed by C. Jimmie Carter. Carter initiated the very popular "Fly-in" Day, bringing thousands of onlookers and many airplanes to the town. Carter is pictured (standing fourth from the left) with airport managers from throughout the area. (Courtesy of the Rogers Historical Museum/Opal Beck.)

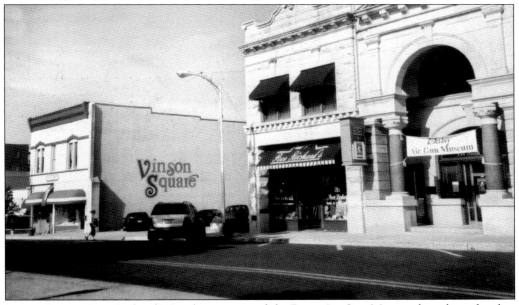

Vinson Square, Poor Richard's Confectionery, and the Daisy Air Gun Museum have been familiar sights along First Street for many years. On the east side of the street is Frisco Park, home to town celebrations and events such as the Frisco Festival, Pickin' in the Park, and the Goblin Parade. The park offers playground equipment and a picnic pavilion year-round. (Courtesy of Marilyn Collins.)

The move of Daisy Manufacturing Company from Michigan to Rogers had a major economic and social impact on the small town. The company hired local companies to construct their plant and supply as many of their needs as possible. When the plant opened in 1958, over 400 local people were hired to help build air guns for sale throughout the country. (Courtesy of the Rogers Historical Museum.)

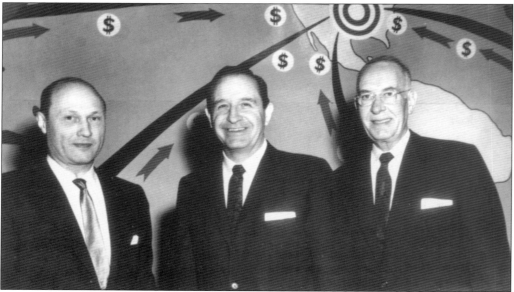

From left to right, Daisy Manufacturing Company president Cass Hough, Arkansas governor Orville Faubus, and Earl Harris were part of a presentation by the Rogers Chamber of Commerce at their 1957 banquet. The $2.5-million payroll and added business from the presence of Daisy helped launch the growing economy of today. The manufacturing portion of the business later moved to Neosho, Missouri. (Courtesy of the Rogers Historical Museum.)

If you spend much time in the Daisy Air Gun Museum at its new location on the corner of Second and Walnut Streets, a man or woman will probably come in and start to tell a story—about the first BB gun they owned or a favorite Red Ryder comic book. Soon they will be totally absorbed in the unusual collection of historic air guns and the history of the "Daisy." Early advertisements make great posters today and are available in the gift shop along with other memorabilia. (Courtesy of the Daisy Air Gun Museum.)

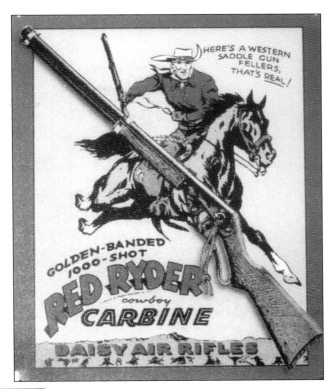

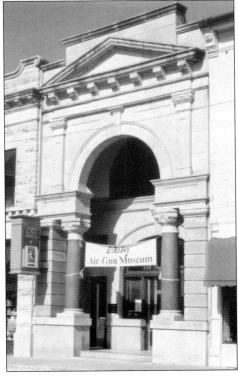

The Daisy Air Gun Museum moved from this location on First Street (the former First National Bank and later home of the Rogers Historical Museum) to the Juhre Building at 202 West Walnut and Second Streets. Past employees of Daisy Manufacturing often volunteer their services to help run the museum. The museum displays pre-Daisy air guns as well as the history of Daisy to today. Reproductions of Daisy air guns, T-shirts, BBs, and Daisy memorabilia are available in the gift shop. (Courtesy of Marilyn Collins.)

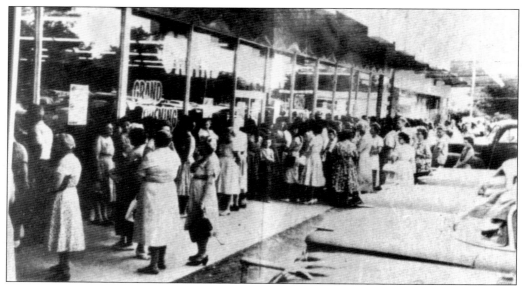

Sam Walton started with a Ben Franklin store followed by Walton's 5&10 store in Bentonville, Arkansas. His first Wal-Mart discount store opened in Rogers in 1962 on the corner of Walnut and Eighth Streets. Several hundred people lined up at the door that day—and as the saying goes, "the rest is history." The designated Store #1 is now at 2110 West Walnut Street. Wal-Mart headquarters are on Walton Boulevard in Bentonville, and the Wal-Mart Museum and Visitors Center is at 105 North Main Street in Bentonville. (Courtesy of the Rogers Historical Museum.)

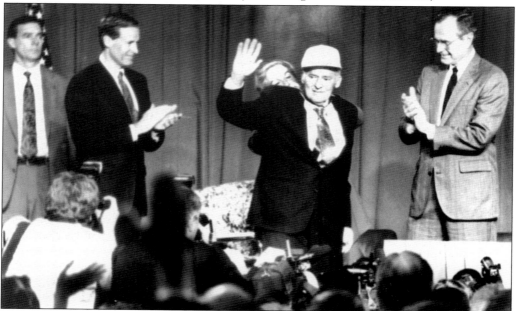

On March 17, 1992, Pres. George H. W. Bush awarded Sam Walton the Presidential Medal of Freedom. Helen Walton joined her husband on the dais as he received the highest award in the nation given to civilians. The inscription read in part, "Sam Walton embodies the entrepreneurial spirit and epitomizes the American Dream." (Courtesy of the Rogers Historical Museum/Flip Putthoff.)

Three

BOUNTIFUL HARVEST

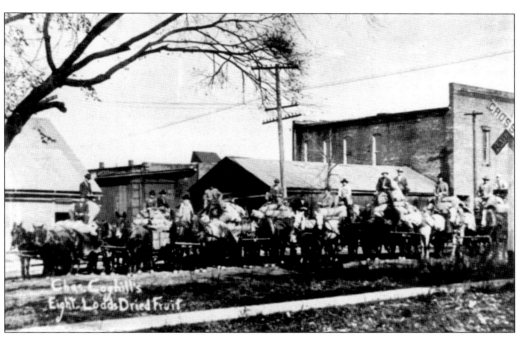

The apple industry opened several levels of jobs and businesses in the Rogers area: growers, pickers, evaporators, vinegar processors, packers/shippers, railroad workers, and many more. In this 1912 scene, drivers for these eight wagons of dried apples lined up at the railway station for shipment. These apples were first processed at Charles Coghill's evaporator near Lowell, packed, and put on wagons for transportation to Rogers and the Frisco Station. The eight drivers are, from left to right, A. T. Roberts, Neelwy Sawrey, R. E. Lillard, Bob McGaugh, Charley Davis, Bill Roberts, Jim Webster (father of Roy Webster, who was the founder of the House of Webster where, among other products, delicious jams and jellies are made), and F. M. Stanford. This photograph was taken behind the Beaulieu Hardware building in the 100 block of Poplar Street. (Courtesy of the Rogers Historical Museum/Roy Webster.)

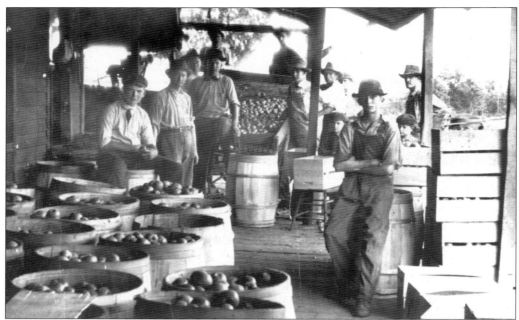

T. A. Winkleman began operation of the Benton County Produce Company in 1906. The county led the nation's apple industry with five million bushels of apples sold at $1 a bushel during its busiest year in 1919. Early apple evaporators often handled 800 to 3,500 bushels a day. (Courtesy of the Rogers Historical Museum.)

Farmers proudly displayed samples from their crops at the Benton County Fair in Bentonville. The first fair started in Rogers in 1888 but moved to Bentonville in 1902. Among the several varieties of apples grown, "Arkansas Black" seemed to be the favorite, with very red skin and sweet yellow fruit. Story has it that a wealthy Cherokee woman had her slaves plant the first apple orchard in Benton County. (Courtesy of the Rogers Historical Museum.)

Men and women made the farming industry successful. Women often worked in the fields, as well as making pies, jams, and jellies. A woman (top picture) proudly shows her basket of large strawberries that seems to also catch the interest of her friendly horse. From left to right below, Ada Wilmouth and Lillie Sherrell, both members of the Minervian Club, are having a good time in the 1930s making apple candy. The Minervian Club was part of the Benton County home demonstration clubs. (Courtesy of the Rogers Historical Museum.)

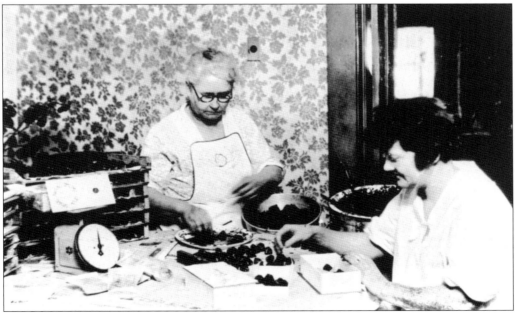

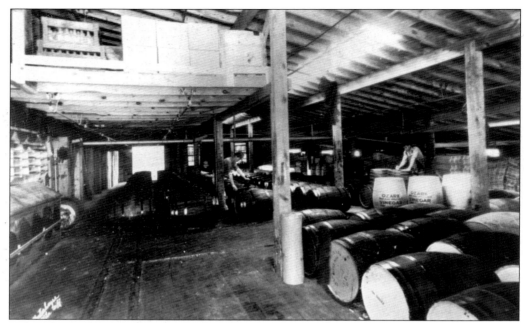

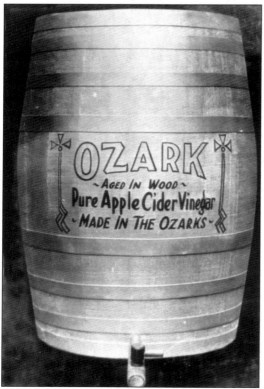

Vinegar was another important by-product of the apple industry. Pictured (top) is the O. L. Gregory Vinegar Works, which was the largest vinegar plant west of the Mississippi. Speas Manufacturing Company bought the company in 1929. Other companies included the Benton County Produce Company owned by T. A. Winkleman, Rogers Wholesale Grocery, Benton County Apple Brandy Company, David and Stephen Wing Evaporator, and the Ozark Cider and Vinegar Company (left). The apple blossom became the state flower in 1901 and was so important that it appeared on car tags until 1939. (Top image courtesy of the Rogers Historical Museum/ Clarice Moore; Bottom image courtesy of the Rogers Historical Museum.)

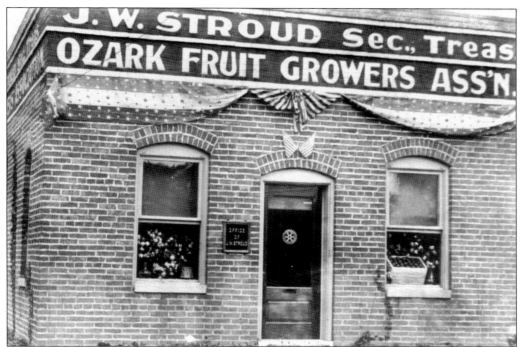

Dollars seemed to grow on apple trees in Benton County. This part of Northwest Arkansas was understandably known as the "Land of the Big Red Apple." Town ordinances even made it unlawful to "willfully or maliciously cut, lop, girdle or in any other manner injure any fruit . . . knock down or injure any fruit . . . or carry away any fruit." However, nothing successfully protected the apple orchards from destruction by San Jose scale and cedar rust diseases, insects, and unusually dry weather. (Courtesy of the Rogers Historical Museum.)

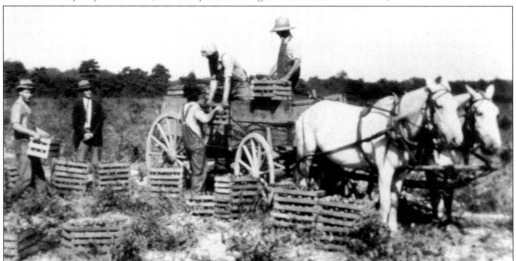

Apples were not the only cash crop on area farms. In this c. 1920s scene, pickers load tomatoes for a cannery on North Second Street on the west side between the railroad tracks. Today the Rogers Farmer's Market provides an ample outlet for home-grown vegetables. (Courtesy of the Rogers Historical Museum/Roy Webster.)

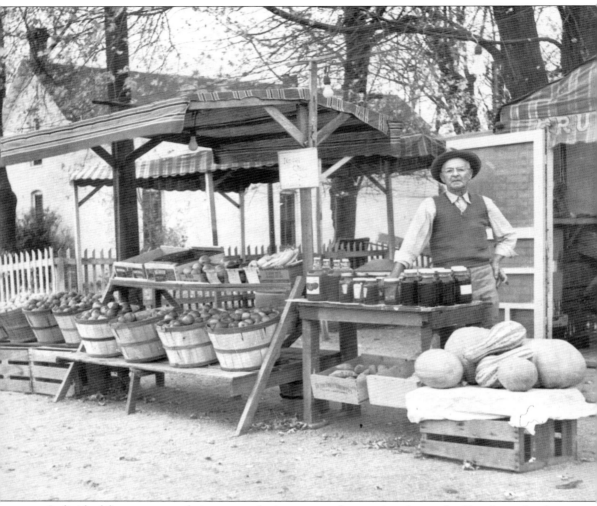

Individual farmers set up their own marketing strategy by meeting the needs of local people who bought from their roadside stands. Joe Head's produce stand was on the site of the future Suzie Q on Second Street. The Farmer's Market on Arkansas Street is a modern-day version of this entrepreneurial spirit. (Courtesy of Patsy Simmons.)

Every member of the family
participated in raising crops for
commercial use and for feeding
the family. This young boy
from Rogers (top picture) is just
tall enough to pick a peach for
himself. Cherries, strawberries,
blackberries, and other fruits also
grew well in Northwest Arkansas.
This c. 1915 scene in Mr. King's
cherry orchard (bottom picture)
shows Cleo Conaway, Gladys
Conaway, and Annie Boyles
picking cherries. (Courtesy of the
Rogers Historical Museum.)

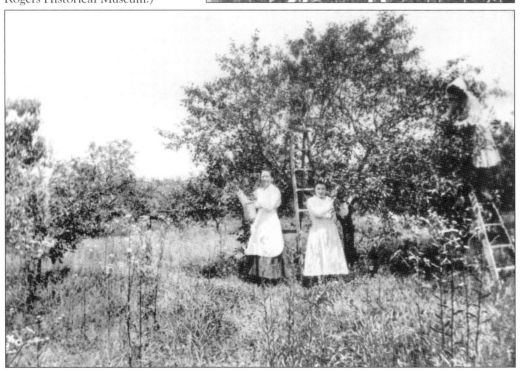

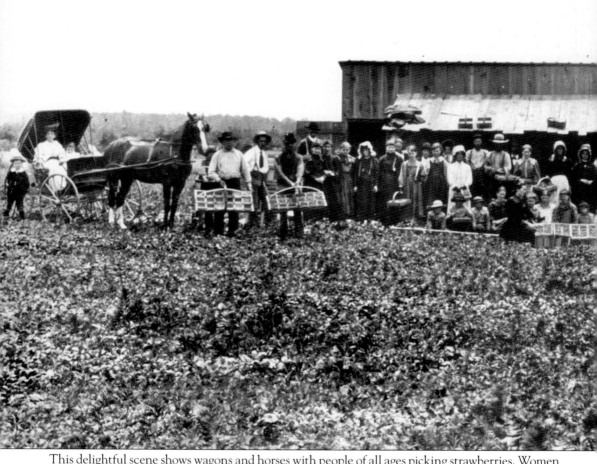

This delightful scene shows wagons and horses with people of all ages picking strawberries. Women have on their bonnets, and men are dressed in pants, vests, and often ties. Panorama pictures like this are often family collector items from that period. This strawberry patch was part of a

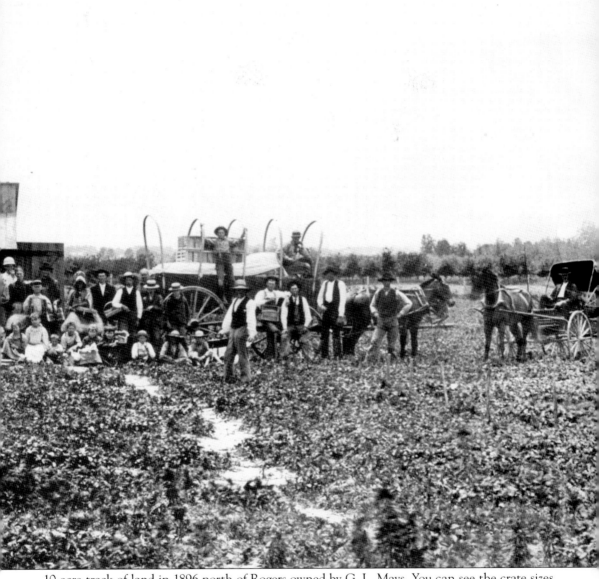

10-acre track of land in 1896 north of Rogers owned by G. L. Mays. You can see the crate sizes pickers had to fill to make their wage for the day. (Courtesy of Jerry Hiett.)

Roy Webster founded House of Webster in 1934, and it continues as a family business today. This wooden building is the first House of Webster, measuring 35 feet wide by 60 feet long. Today the company fills two acres with buildings. The House of Webster grew from those early days to a large firm that ships jams, jellies, and other products nationwide. (Courtesy of the Rogers Historical Museum/Roy Webster.)

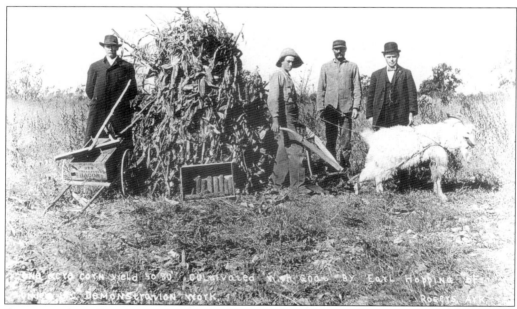

Corn was also a favorite crop grown in the area. According to this picture, one acre of corn yielded 50 bushels. Farmers cultivated this field with a plow and, in this picture at least, a goat. (Courtesy of Jerry Hiett.)

In the 1930s, people in town often grew a small garden in their backyards. Malcolm and Martha Susan Allred enjoy their garden on North C Street in Rogers. Another farmer takes a personal interest in his livestock. A farmer with a horse, plow and wagon, garden, a few chickens, and cows could be self sufficient. (Top image courtesy of Richard Bland; Bottom image courtesy of Opal Beck.)

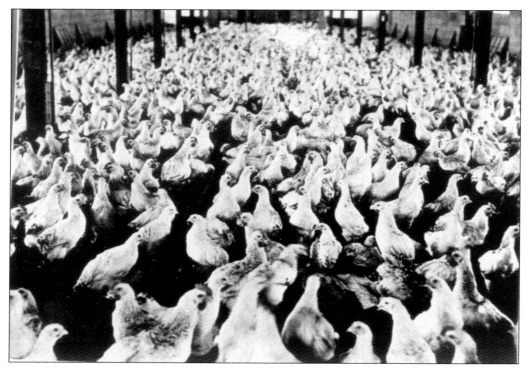

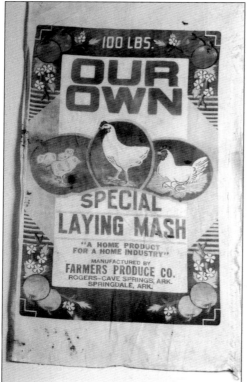

The chicken business grew from the small farmer raising a few chickens in a pen to long brooder houses similar to the one pictured above. Large companies such as Hudson, Tyson, Peterson, and George's supplied farmers with baby chicks, food, and other supplies and then purchased the chickens when they reached broiler size. Benton County was known for its Vantress Cross chicken and the Arkansas White Rocks. (Courtesy of the Rogers Historical Museum.)

"Our Own" special laying mash manufactured in Rogers, Cave Springs, and Springdale, Arkansas, was touted as "A Home Product for a Home Industry." Feed bags had a second usage. When the bags were emptied, they were washed and used to make dresses and other clothing. True to human nature, these items are now valued by collectors. (Courtesy of the Rogers Historical Museum.)

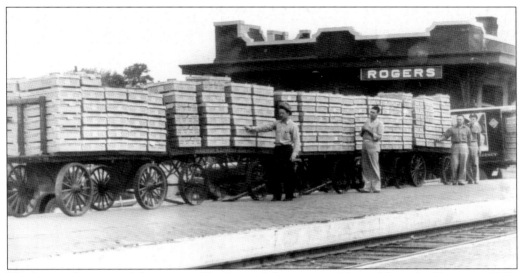

The largest shipment of chickens in Northwest Arkansas was delivered by rail to Rogers in 1948. Over 40,000 day-old chicks, consigned to C. Jimmie Carter, were on the ticket that day. During those five years from 1948 to 1951, a record number of 20 million chicks were flown to the Rogers Airport. These chicks were then raised by local farmers and resold to the various poultry companies. (Courtesy of the Rogers Historical Museum/Opal Beck.)

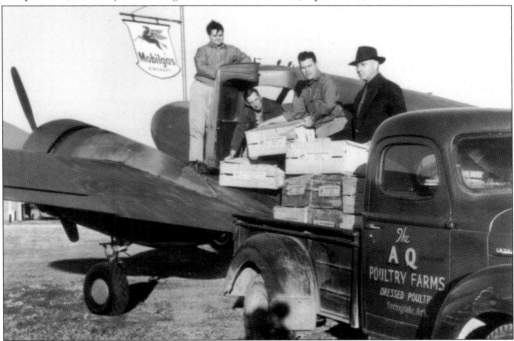

The Rogers Airport increased in importance as it became the hub for shipping poultry in and out of the area. The shipment shown is of Arkansas broilers on their way to Alaska via Tulsa by Rusty Air Service. Pictured from left to right are Jay Frizzo, pilot; Frank Rust, president of Rusty Air Service; Howard Backus, vice president of A. Q. Chicken Farm; and C. Jimmie Carter, president of the Rogers Airport Corporation. (Courtesy of the Rogers Historical Museum/Opal Beck.)

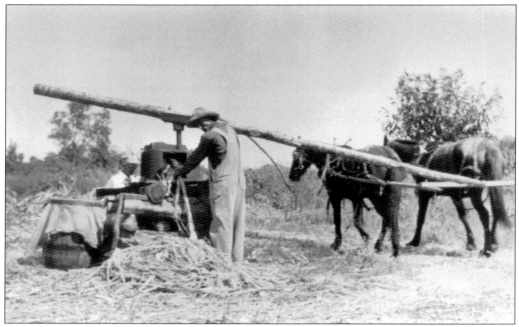

Molasses or sorghum was made by grinding sorghum and extracting the juice. A mule or horse was hitched to a pole and provided the turning power to grind the cane. A deep track was usually formed where the mule made thousands of circles to grind the cane. Workers were often rewarded a taste while the molasses was being made. (Courtesy of the Rogers Historical Museum.)

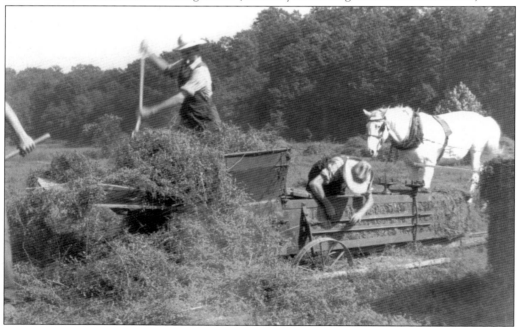

Hay was grown by local farmers for livestock feed and for bedding. After the hay was cut, men used a horse-drawn wagon and large pitchforks to help them with their work. (Courtesy of the Rogers Historical Museum.)

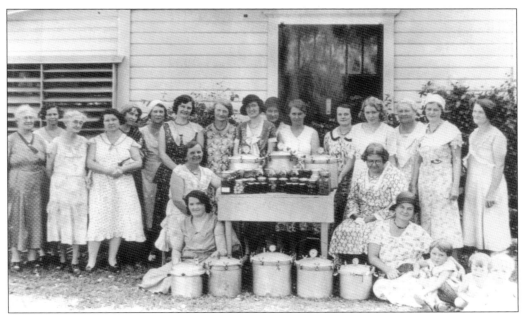

Various home demonstration and community clubs brought women together to help preserve the fruits of the harvest. Demonstrations in canning, making jelly, sewing, and other skills needed for the home and farm were part of the friendly gatherings. The Minervian Club founded in 1919 was the first home demonstration club in Benton County. They even built their own clubhouse with the help of their husbands, using local rocks and raising money for the other materials. (Courtesy of the Rogers Historical Museum.)

Club members often made home visits and toured the pantries or root cellars where members were storing and preserving fruit and vegetables from their fields. This gave the members an opportunity to show the efforts of their hard work and exchange recipes or other homemaking tips. Members in this scene are visiting the home of Mrs. Clint Harris. (Courtesy of the Rogers Historical Museum.)

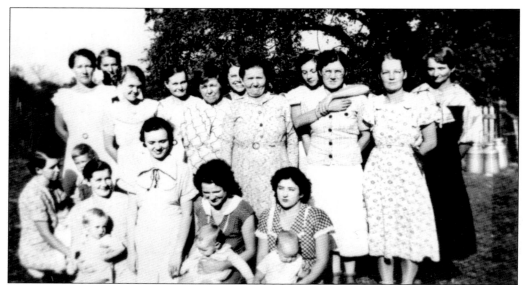

Handcrafts are both useful and beautiful. They were the focus for many area community clubs, like the nearby Help One Another of Larue in the 1930s. Meetings often centered on members who took the opportunity to show their work and learn from each other. Quilt patterns were exchanged and other homemaking tips were discussed. As communities around Rogers grew, showing homemade crafts became a more widely popular and commercial, organized event. (Courtesy of Richard Bland.)

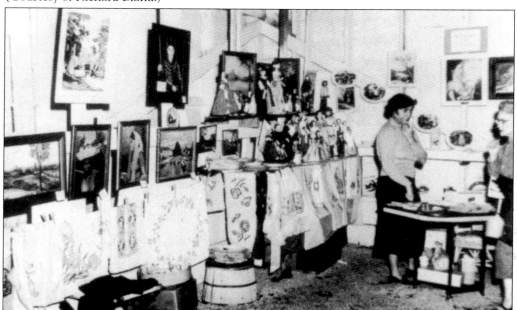

Craft shows were first held in a barn, as shown in this 1950s scene at War Eagle. The first designated craft show was held in 1954. Now over 225,000 visitors come to the largest May and October collective gathering of crafters in the country. Shows, including those at Ole Applegate Place, Clarion Hotel, Frisco Mall, and War Eagle, are part of the extended Northwest Arkansas Arts and Crafts Festival. (Courtesy of the Rogers Historical Museum.)

Four

SCHOOL DAYS

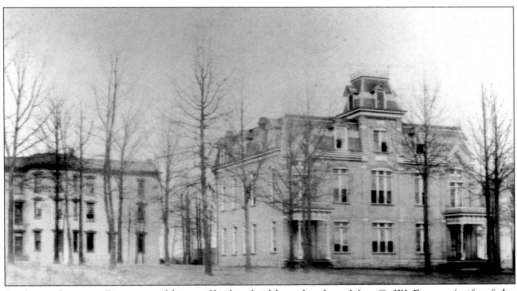

In the early years, Rogers could not afford to build a school; so Mrs. C. W. Rogers (wife of the town's namesake) arranged for the First Congregational Church in St. Louis to "adopt" Rogers as a mission and help provide funds to build the school and pay the teachers. The town provided the land and half the building costs. In 1887, the first graduating class had two students, and the last class in 1913 had eight graduates. The largest class, of 22 graduates, was in 1896. The school was academic even by today's standards, offering several foreign languages, the sciences, higher math classes, and the opportunity to play various instruments. Rules were strict but not seemingly harsh. Young people today would be horrified that a girl was only allowed three dates with a young man during a single academic year. In 1914, the school building was transferred to the Rogers Public Schools. (Courtesy of Shirley and Dean Park.)

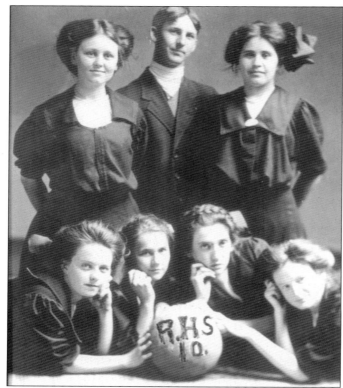

The 1910 Rogers High School girls' basketball team were attired in the latest, fashionable uniforms. Suited out are, from left to right, (first row) Irene Forsyth, Anna Minnie, Mel Saunders, and Lena Todd; (second row) Norma Russel, Coach Bert Phillips, and Ruth Taylor. Miss Jesse Hayes was the first coach of the basketball team in 1900. (Courtesy of the Rogers Historical Museum.)

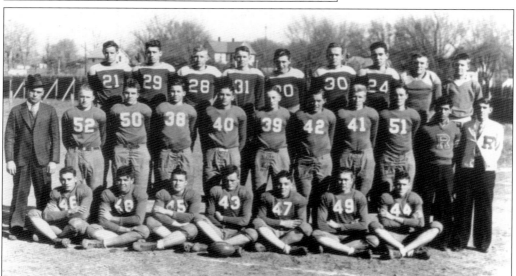

Coach "Doc" Ledbetter was the coach for this 1935 Rogers High School football team. Included in this picture are Roger Greenwood, Dewey Boydston, Eddie Bishop, Paul Belts, Phil Kirksey, Wayne ?, John "Sonny" Erickson, Coach Ledbetter, Warren Musteen, Ralph Smith, Andrew Mitchell, Robert Boydston, ? Jacobs, Fred Rakes, ? Garner, Ray Harris, C. H. Hudspeth, William Skaggs, James Woods, Buddy Green, and Bill Keener. More than half the team in the first football game in 1900 had never played the game before. (Courtesy of the Rogers Historical Museum.)

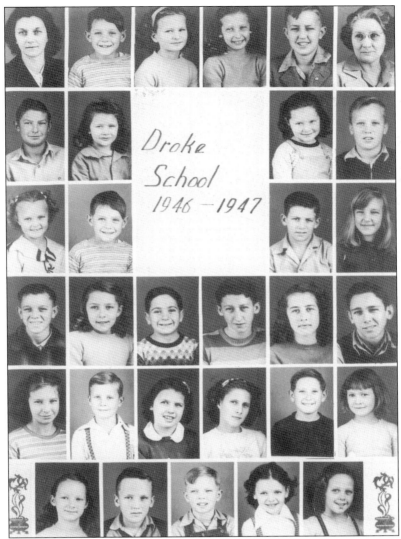

Community schools were responsible for children's education before consolidation began in 1929. They were the center of community life for education, entertainment, and social gatherings. At Droke School on Highway 71 between Rogers and Bentonville, one teacher taught grades one through four, another five through eight. While the teacher was working with one class, older students often helped the younger ones with their work. Pie suppers, Christmas pageants, and other holiday programs were annual events. For Christmas, a huge tree was brought in and each child was given a brown paper sack with an orange, striped-ribbon candy, chocolates, and candy canes. Shown from left to right and top to bottom are all eight classes in the 1946–1947 school picture: (first row) Merle Haga, teacher; unidentified; Virginia Sue West; Marilyn Harris; Danny Moore; and Bethel Hammontree, teacher; (second row) Everett Dean; unidentified; Robin ?; and Gene Gore; (third row) two unidentified; Bobby McFall; and Nancy Moore; (fourth row) unidentified; Barbara Harris; unidentified; John D. Murphy; Shirley Harris; and unidentified; (fifth row) Ethel Mae Dean; unidentified; Betty Divin; Anita Carlisle; unidentified; and ? Garrett; (sixth row) Marybeth Trumble; unidentified; Danny Rakes; Sherrie West; and unidentified. (Courtesy of Shirley and Dean Park.)

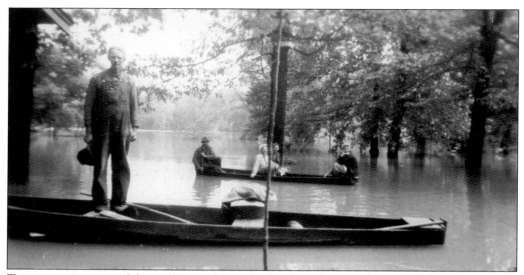

Transportation to and from these early rural schools took many forms. Opal Beck taught at the Monte Ne School near Rogers and recalls how the Tipton family handled sending their five children to school when the river flooded. Arthur Tipton and his wife, Nancy, sent their children—Gilbert, Emory, Selby, Clara, and Opal—to school in the rowboat they conveniently tied to their front porch. (Courtesy of Opal Beck.)

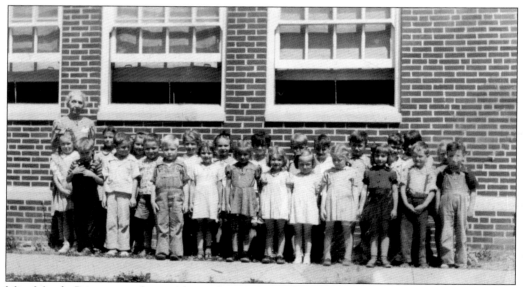

Miss Myrtle Price was a first-grade teacher at Central Ward Elementary School. Pictured here is her class of 1940–1941. From left to right are (first row) Franklin Baker, John Brandon, John Holyfield, Donald Clark, Virginia Kelly, Patsy Judd, Gaynel Moore, Karen Huff, Barbara Harris (visitor), Leah Jean Werner, John Charles Ballard, and L. V. Brewer; (second row) Evelyn Lewis, Edith Jordan, Ramona Brust, Shirley Ann Harris, Nancy McConnaughey, Ronnie Balmer, Charles Templin, Wayne Garrett, Michael Rea, John Linden Miller, Cora Lue Dean, and Edna Cottenbrock. (Courtesy of Shirley and Dean Park.)

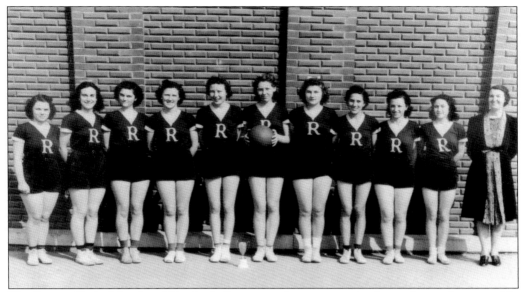

The Rogers High School girls' basketball team uniforms certainly changed over the years. No large hair ribbons or bloomers are in this 1950s team picture. Betty Sue Kirksey is in the center holding the basketball. Leith Worthington, English teacher and senior class sponsor for many years, coached the team. (Courtesy of the Rogers Historical Museum.)

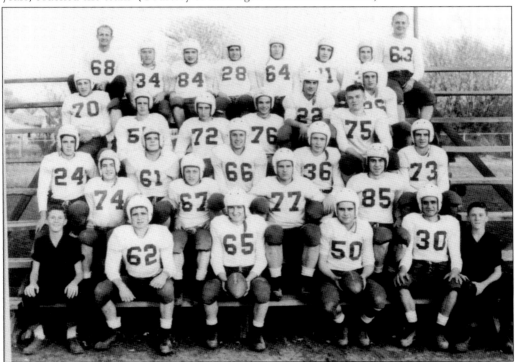

The 1949 Rogers High School football team proudly displays their numbers. Coach Bob Matthews, upper left, was a favorite teacher and coach. Coach Baird is at upper right. The student managers were Jimmy and Billy Strong. (Courtesy of the Rogers Historical Museum.)

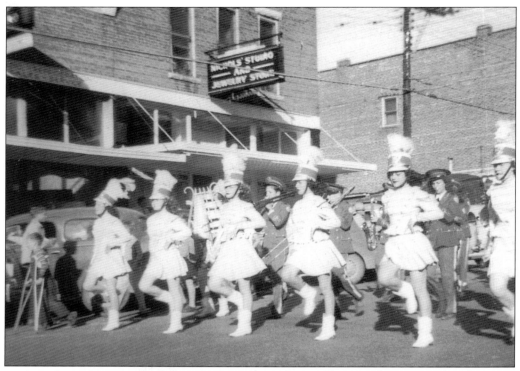

Everyone loves a parade. The Rogers High School Band was and still is a part of town and school celebrations. The majorettes in this scene lead the band down Walnut Street to the enjoyment of crowds lining the streets. Whether the event was the high school homecoming, soldiers coming home from war, or other downtown celebrations, the band led the way. (Courtesy of Sam Wood.)

When the crowds got to the football game, Rogers High School cheerleaders and the Blue Demon Drill Team took over building excitement for the team and cheering them on, hopefully to victory. Uniforms for cheerleaders have also changed over the years from this mid-1950s scene to today. (Courtesy of the Rogers Historical Museum.)

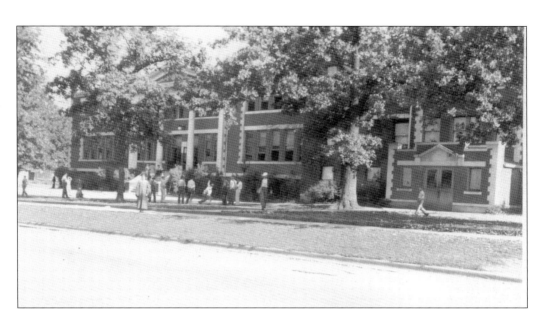

Rogers High School had an open campus in the 1950s. Students could walk home to lunch or go to one of the little stores next to the campus. Students often sat on the curb in front of the high school during lunch break. The Rogers Pharmacy—a drug store with a soda fountain on the corner of Second and Walnut—also served lunch, providing the best toasted chicken salad sandwiches along with chocolate or cherry coke. Charlene Haskell, a 1949 Rogers High School graduate, painted this picture of the "little store," as it was often called in those days. Rife store was also one of the nearby places to get snacks for lunch. (Top image courtesy of Gary Townzen; Bottom image courtesy of Charlene Haskell.)

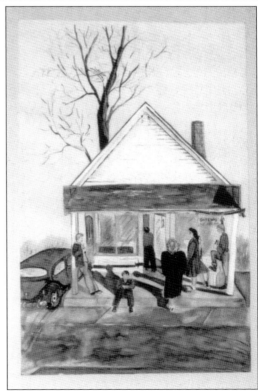

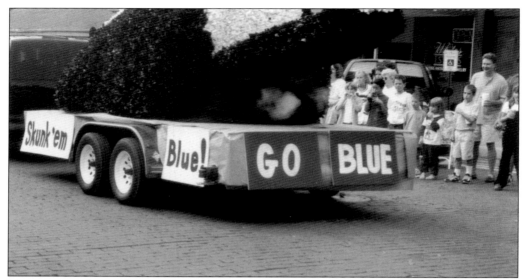

Homecoming floats take many hours to decorate in time for the parade. Floats in this 1998 parade proudly support the Mounties team with "Go Blue" and "There's no place like Homecoming" signs. Downtown merchants tie blue ribbons to the street lampposts to support the team and put encouraging signs in their windows. (Courtesy of Opal Beck.)

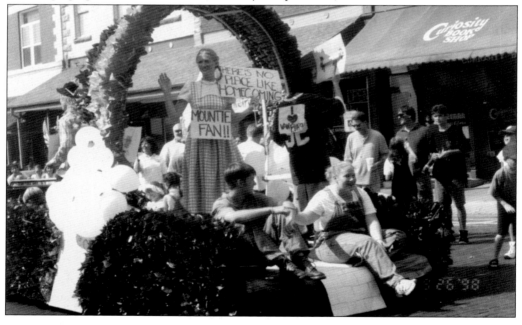

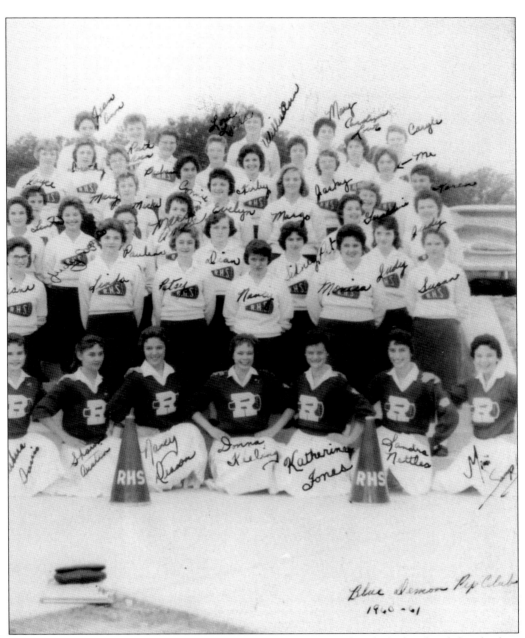

The Blue Demons Drill Team helped support the athletic teams and, with the band and cheerleaders, performed at games. The white coveralls of the 1950s transformed to more attractive garb in this 1960–1961 Demon Pep Club picture. Each girl signed her picture for posterity. (Courtesy of the Rogers Historical Museum.)

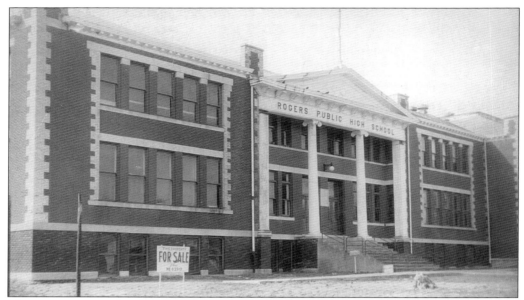

Many memories surfaced when the Rogers High School land went up for sale, bringing along the demolition of this building. Regions Bank filled the new site, and ironically the new Rogers School Board Office has now moved into that building. Students recall the crowded locker rooms, large study hall with creaking floors, mayhem of changing classes, fire escape chute on the side of the building, and stories that—according to the school song—came from "the band room at old Rogers High." (Courtesy of Jerry Hiett.)

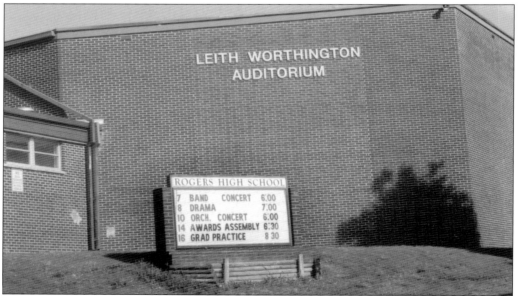

Rogers schools today carry the names of outstanding teachers, coaches, or other educators of past years. The auditorium of the second Rogers High School was named in honor of Leith Worthington, an awesome senior English teacher. She was often elected senior class sponsor in charge of the senior play. She demanded the best from her students and usually got just that—for some, the class was the first time they believed it possible to excel. (Courtesy of Marilyn Collins.)

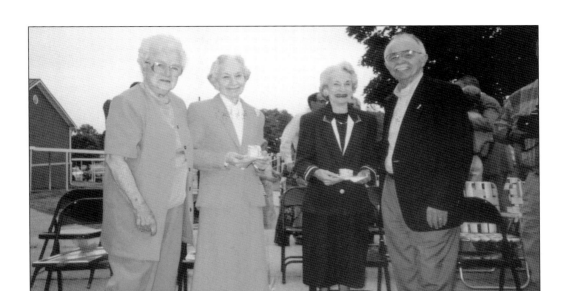

Most students can recall a special teacher or coach who inspired them or changed their lives. Two such teachers were Betty Lynn and Mary Sue Reagan, to whom, along with their sister Agnes Lytton, this book is dedicated. The two former teachers are honored here by the City of Rogers for outstanding contributions to education. Pictured with other strong advocates for education are, from left to right, former teacher and owner of Mode 'O Day dress shop Opal Beck, teachers Betty Lynn Reagan and Mary Sue Reagan, and Dick Trammel of Arvest Bank. (Courtesy of Marilyn Collins.)

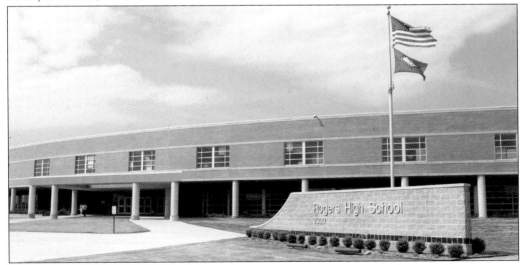

Student enrollment has steadily increased since the first Rogers High School on Walnut Street graduated its last class in 1960. The building was torn down in 1962. The second high school opened in 1961 on Fifth Street and is currently houses the sophomore campus. Pictured is the third Rogers High School, which opened in 2001 at Perry Road and Dixieland Road. A second high school is in the planning stages and possibly a third high school may be needed to handle the growing population. (Courtesy of Luke Brewer.)

The spirit of "old Rogers High" is kept alive during class reunions, where former students can renew acquaintances with greetings of "what's your name again" and talk about old times. A committee formed by Sue (Beck) Fleming planned a reunion for all students graduating in the years from 1950 to 1959. Keeping in the 1950s theme, the reunion was held at Birch Kirksey Middle School. Birch Kirksey was the superintendent of schools during the 1950s. Pictured from left to right are Joyce Givers, Sue Fleming, and Ted Givers. (Courtesy of Shirley and Dean Park.)

The Rogers High School class of 1952 began holding a reunion every five years after their 10-year anniversary. Pictured is their 45th reunion with Mrs. Lon Price (art teacher) at center left and Mrs. Jessie Holyfield (second-grade teacher) at center right as honored guests. After their 45th anniversary, members met every year to prepare for their 50th reunion celebration held in 2002. They are now planning for their 55th reunion.

Five

PLACES OF WORSHIP

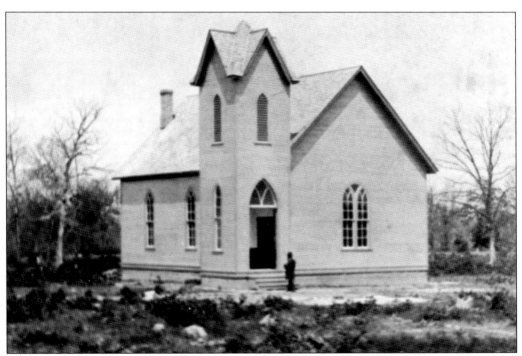

Mrs. Mary Shaw Rogers, wife of the town's namesake, C. W. Rogers, was not only instrumental in establishing the first school (Rogers Academy) in town but also helped organize the first church. She was a member of the First Congregational Church in St. Louis and helped organize a church of that denomination in Rogers. It was built in 1882 on the corner of Second and Poplar Street. The bishop of Arkansas stands in the foreground of this scene. Streets around the church were dirt and often mud. Stumps and brush surrounded the building. This church later merged with the First Presbyterian Church. After a couple more moves, a new church building was designed by A. O. Clarke and built in 1914. The Mutual Aid Building, later called Poplar Plaza, was located on this site. (Courtesy of the Rogers Historical Museum.)

Mrs. J. F. McGiney taught this Sunday school class at the Congregational Church in Rogers. Members of the class are formally dressed in suits and ties. In attendance were ? Marshall, Earl McGinley, Clarence Hunter, George Hunter, Ira Baker, and Timothy Applegate. (Courtesy of the Rogers Historical Museum.)

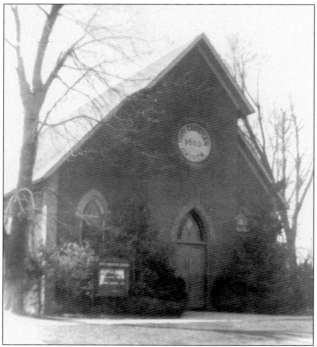

Another early church was the First Christian Church in Rogers, organized in 1886 and originally built on the corner of Third and Poplar Streets. Early members pledged themselves to "love one another and to work in harmony." The Riggs, Stroud, Hensley, Minnick, Fowler, and Benton families were among early members. (Courtesy of the Rogers Historical Museum.)

Both men and women traditionally served in the church. The above 1929 men's Bible class of the First Christian Church is an example. Women also volunteered as teachers, altar guild members, flower arrangers, helpers for congregation members in need, and as part of the church staff. This group of women c. 1905 belonged to the Cumberland Presbyterian Church in Rogers. They include Elizabeth Hawkins (standing second from the left), Mrs. Charles Juhre (short lady right of center), Mrs. ? Rearick (second from the right), and Helen Dunham (far right). (Courtesy of the Rogers Historical Museum.)

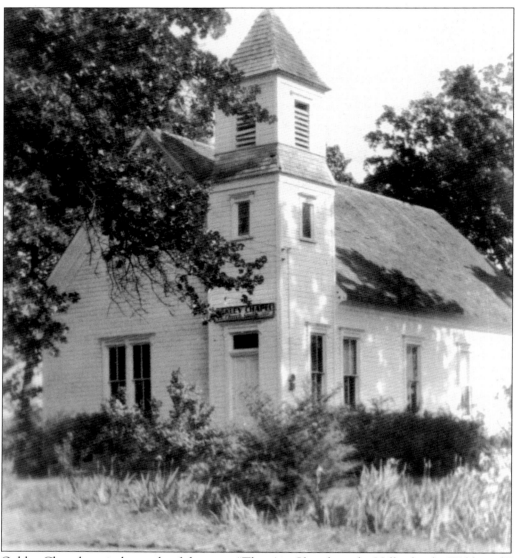

Oakley Chapel reminds people of the song, "There's a Church in the Valley by the Wildwood," as it stood out in the country between Rogers and Bentonville on Highway 71. Today commercial buildings surround the church and a four-lane highway runs beside it. The church was first organized in the Droke schoolhouse in 1869. The Oakley family was very involved in the little church, including donating land for the original structure built in 1872. Three Oakley members sat on the first board of trustees—O. J., Haywood, and Elsby—as well as G. W. Droke and S. H. Shelton. Jim Oakley was the superintendent of the Sunday school. For many years, the pianist for the church was Audra McFarlin Rakes. Some of the oldest settlers are buried in the cemetery beside the church. (Courtesy of the Rogers Historical Museum.)

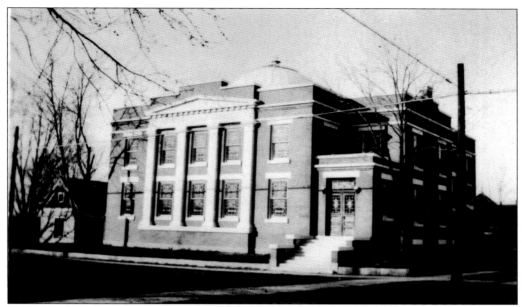

Over the years, the First Presbyterian Church moved to several locations in Rogers. The top picture shows the building designed by A. O. Clarke as it stood in 1914. B. F. Sikes donated the land for this building on 403 West Walnut Street. The Frisco railroad provided free shipment of materials from St. Louis to help build the church. As the city and population patterns began to move mostly south and west of town, the structure was torn down (bottom) in July 1994. A new church was built on South Twenty-Sixth Street in Rogers. (Courtesy of the Rogers Historical Museum.)

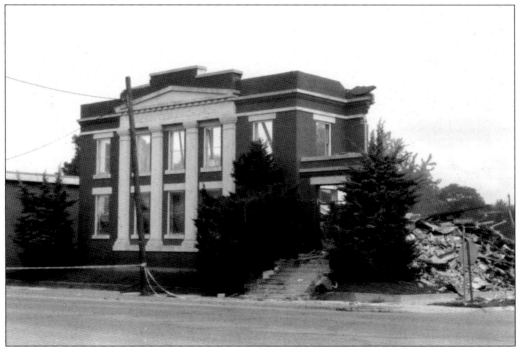

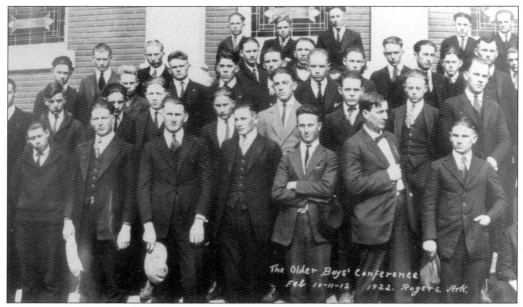

Both men and women were active in church programs in Rogers. Pictured are young boys and men attending the Older Boys Conference in 1922 sponsored by the First Christian Church. (Courtesy of the Rogers Historical Museum.)

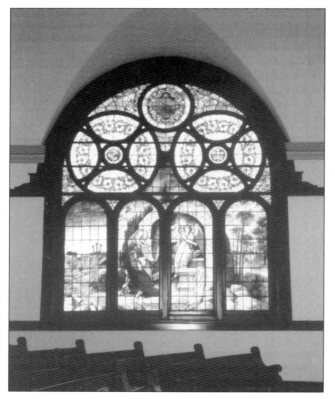

The Resurrection Window is on the middle south wall of the First United Methodist Church at Elm and Third Streets in Rogers. The window, given in memory of Benjamin Franklin Sikes and Tabitha Sikes, is just one of many beautiful stained-glass windows in this church, earlier called the Central United Methodist Church. The story of the resurrection is told by the window, including the three women—Mary Magdalene, Mary the mother of Jesus, and Salome—who came to the tomb looking for Jesus after his crucifixion. (Courtesy of the Rogers Historical Museum/First United Methodist Church.)

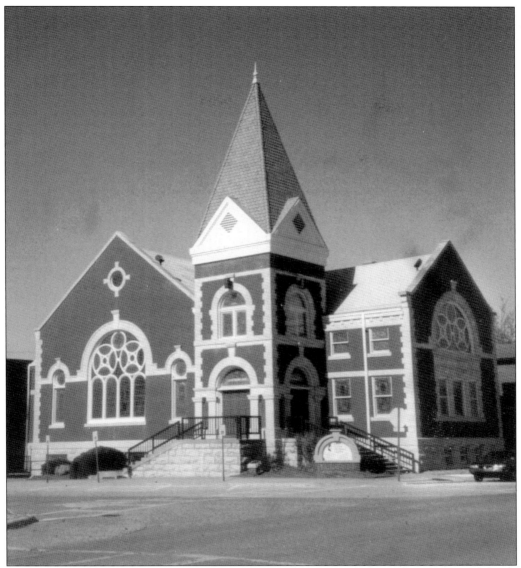

In the late 1880s, two early Methodist Episcopal churches came to town—Methodist Episcopal Church, South and the First Methodist Episcopal Church, North. Churches were defined not by the direction in town where their buildings stood but were named based on where they stood politically. The two churches consolidated their congregations in 1937 into a single church, designed by A. O. Clarke and built on Elm and Third Streets. The combined congregations became the Central United Methodist Church. In 1994–1995, part of the congregation built a new church on New Hope Road and Twenty-Sixth Street, keeping the name Central United Methodist Church. The congregation remaining downtown took the name First United Methodist Church. Other downtown churches have also moved farther south and west of town, some maintaining two congregations and others selling their downtown building. (Courtesy of Marilyn Collins.)

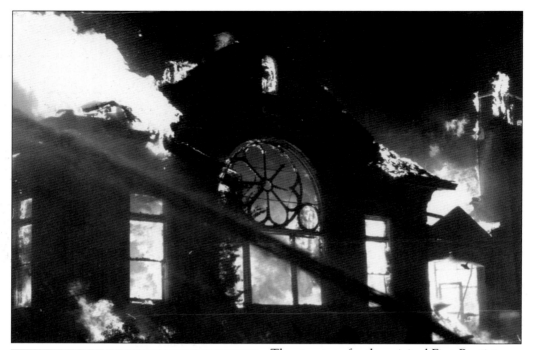

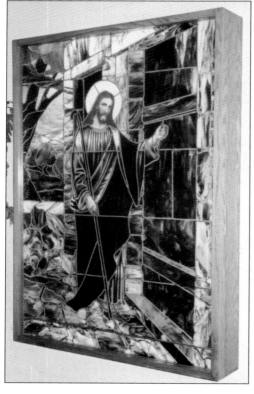

The structure for the original First Baptist Church burned, as did this later church on the corner of Cherry and Second Streets. The land was given to the church by J. Wade Sikes and dedicated in 1905. The church was an A. O. Clarke design. The leaded-glass windows, dominated by a large figure of Christ knocking at the door (of our hearts), were also designed by Clarke and colored by the manufacturer. Removed before the fire, the stained-glass window of Christ (left) stands in the entry foyer of the current First Baptist Church on Eighth and Olive Streets. Plans for a new sanctuary are currently underway to be built on Bellview Road. Like many other congregations in downtown, the church is striving to meet the needs of the growing population south and west of the city. (Top image courtesy of Gary Townzen; Bottom image courtesy of Marilyn Collins.)

Rev. Jasper Dunagin with Rev. W. W. Harris and Rev. George C. Harris organized the First Baptist Church in 1883 with only five members: Mrs. C. D. Rearick, Lula Rearick, Mrs. Alice King, Mrs. ? Pagett, and A. D. Leggett. The first pastor of the church was Rev. Jasper Dunagin. Wanette Bender is pictured in front of the second church building on Cherry and Second Street. Wanette was a teacher in the vacation Bible school (VBS) in 1952. VBS was a traditional part of summer education for children in many churches in town. This large group in the mid-1940s is standing on the front steps of the church as part of the VBS at First Baptist Church, led at that time by the Reverend Rel Gray. (Courtesy of Shirley and Dean Park.)

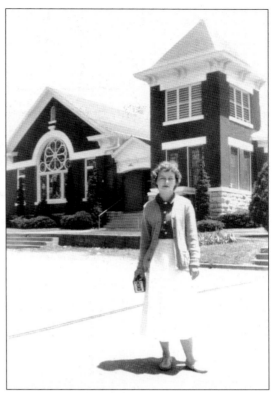

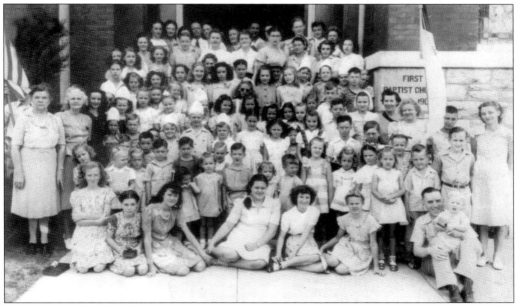

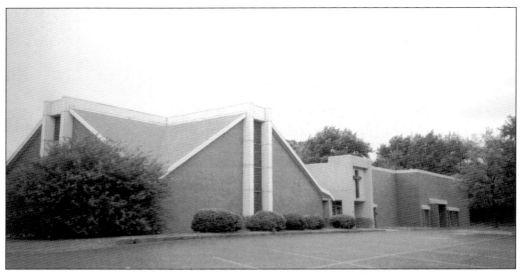

Peace Lutheran Church on Olrich Road in Rogers is currently expanding from the church pictured here. A new center to be located on Bellview Road south of Rogers will mainly focus on their youth ministry. All aspects of the design are done with young people in mind—polished cement floors, exposed structure ceilings, paint colors, game room, and even doors are different. The new facility will also include a café. The church plans to use both facilities when complete. (Courtesy of Marilyn Collins/Peace Lutheran Church.)

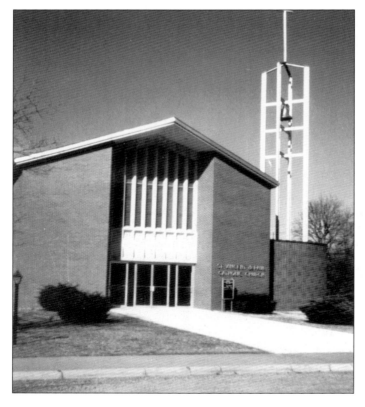

St. Vincent de Paul began as a mission established in Rogers in 1910. The first sanctuary (the current Parish Hall pictured here) and new facilities touch both Cypress and Poplar Streets. The church dedicated a new sanctuary in 2003 with a congregation of over 1,500 people. In reaching the present ethnic changes in the area, 52 percent of the congregation is now Spanish-speaking. The church has also sponsored an elementary school first run by nuns. The current school of 355 students is administered by lay people. (Courtesy of the Rogers Historical Museum.)

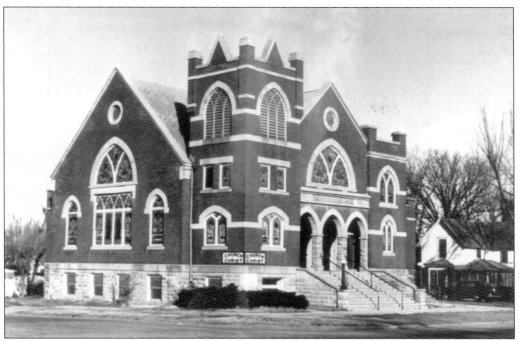

The Church of Christ in Rogers organized in 1913. They purchased this structure on Second and Chestnut Streets from the First United Methodist Episcopal Church in 1938. In the early 1970s, the church was torn down, and the current downtown Church of Christ is at 201 West Chestnut. (Courtesy of the Rogers Historical Museum.)

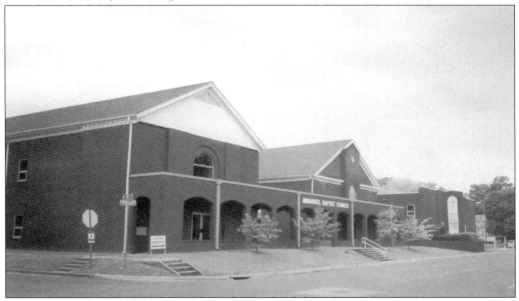

The current Immanuel Baptist Church is at 506 West Poplar Street. Three years ago, the church purchased 40 acres on Twenty-Sixth Street, and site preparations are now underway. Many area residents have enjoyed the musical/theatrical Easter Drama presented each year by members of the church. (Courtesy of Marilyn Collins.)

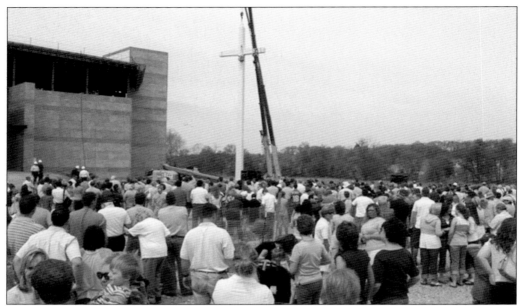

The First Baptist Church in Springdale will be extending their services to the Church at Pinnacle Hills on Pinnacle Parkway in Rogers. A 145-foot cross is being raised before a large group of worshippers on Good Friday, April 14, 2006. Two more crosses will be added in early fall, when the dedication for the new building is planned. (Courtesy of Luke Brewer.)

Different from most of the churches currently building large facilities west and south of town, Fellowship Bible began with small groups in homes and then used space in existing buildings until they built their first church building(s), dedicated in 1991 on New Hope Road. At the time of purchase, the property—a large field on a two-lane road—was part of the city of Lowell. The church is now surrounded by rapid growth—including their own with increasing membership. (Courtesy of Fellowship Bible.)

Six

FOR THE FUN OF IT

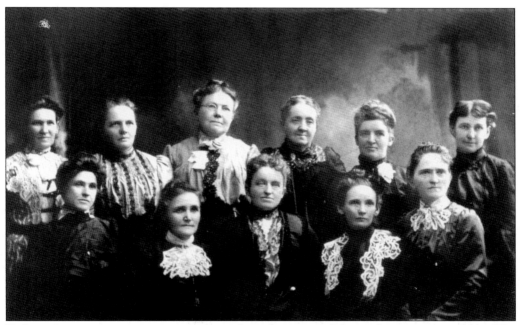

Early in America, various organizations took on the responsibilities of community welfare. The Mas Luz Reading Club, which became the Women's Study Club, started the first public library in Rogers. The Minervian Club and other home demonstration clubs helped women make the most of the produce and material they had to preserve food, make quilts, and learn other helpful homemaking tips. Pictured here are the ladies in 1902 who were members of the Rocking Chair Club: Amelia Blake, Sarah Bailey, Mrs. W. A. Miller, Mrs. Jackman, Mrs. Phillips, Mrs. Dougherty, Mrs. Adams, Mrs. Adamson, Mrs. Will Scott, Mrs. John Stroud, Lillian Hawkins, and Lizzie Miller. (Courtesy of the Rogers Historical Museum.)

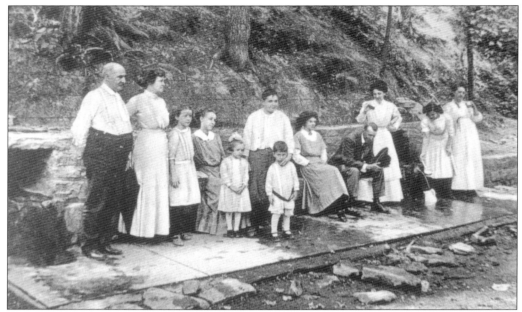

Water from Electric Springs, near Rogers, reportedly had healing qualities or "electricity." Supposedly putting a piece of metal in the water magnetized it. People flocked for the cure to a nearby hotel built by H. B. Horsley in 1867. In this 1936 scene, a family enjoys the waters. You can still see the three channels of spring water trickling out of the hillside beside Highway 12. (Courtesy of the Rogers Historical Museum.)

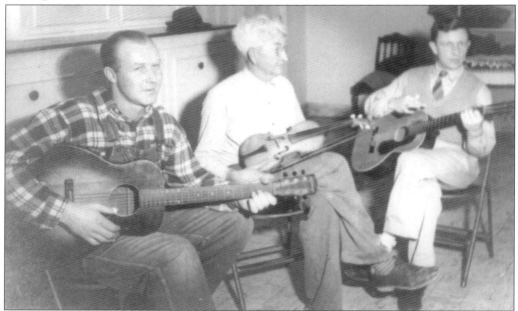

Music is a part of almost every gathering held in the early Ozarks. What could be more colorful and authentic than fiddlers playing at the Rogers Townhouse in 1945 for the Possum Hunter's Banquet? Pictured from left to right are Earl Jones, Bill Matlock, and Bill's son Henry Matlock. (Courtesy of the Rogers Historical Museum.)

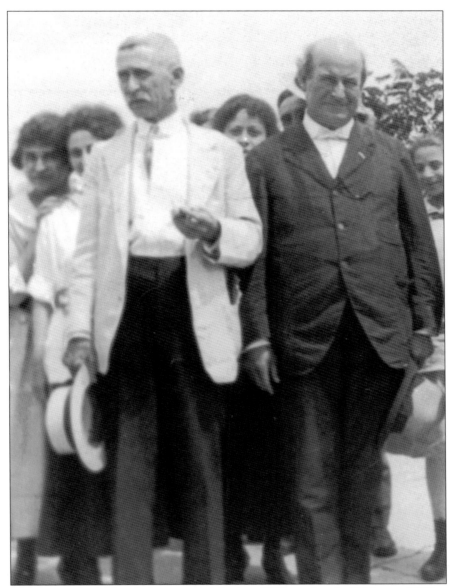

One of the most colorful local characters of the late 1800s and early 1900s was William Hope "Coin" Harvey (left) pictured here with William Jennings Bryan at his dream resort in Monte Ne. Despairing over the political system of the late 1800s, Harvey purchased 320 acres in Monte Ne for a resort complete with rustic hotels and a gondola to ferry people across the creek from the train to their hotel. His efforts failed as a hotelier, author, Liberty Party candidate for president, and advocate for the silver standard for this country. Harvey then turned his energies to a more lasting project. Feeling that civilization as he knew it would come to an end, he began building what was to be the site of a pyramid to house artifacts and information, including copies of his books, all to be found by future generations. But he only completed the amphitheater portion of the project, which local residents called "the pyramids." Beaver Lake flooded the initial structure in the mid-1960s. Visitors still flock to see remnants of the amphitheater, which are visible today when the lake is low. (Courtesy of the Rogers Historical Museum.)

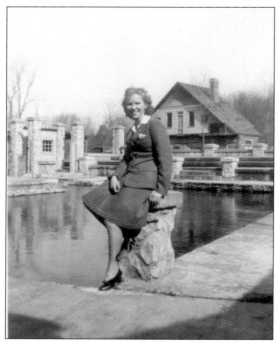

Local people loved to have their pictures taken on the still-standing structure of the amphitheater at Monte Ne. This picture of Dorothy Sholts was taken in 1943. The building in back of her is the depot for the five-mile railroad spur Coin Harvey built from Rogers to bring more tourists to his resort at Monte Ne. Harvey organized the Ozark Trails Association in 1913, which numbered roads to make it easier for travelers to find their destination and, of course, his resort. (Courtesy of Sam Wood.)

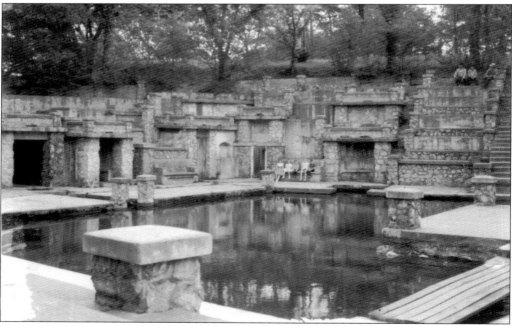

Driving to Monte Ne filled many Sunday afternoons for local families. The children could climb on the "pyramids' " cement steps, sit on the cement couches and chairs, and peer into dark entryways that were to have held objects of Coin Harvey's time for future civilizations to find. DeAnne McIntire (now Dr. DeAnne Witherspoon) used to play here with her brothers and sister. Pictured in 1959 are, from left to right, DeAnne, Robert, Jan, and John McIntire. (Courtesy of DeAnne Witherspoon.)

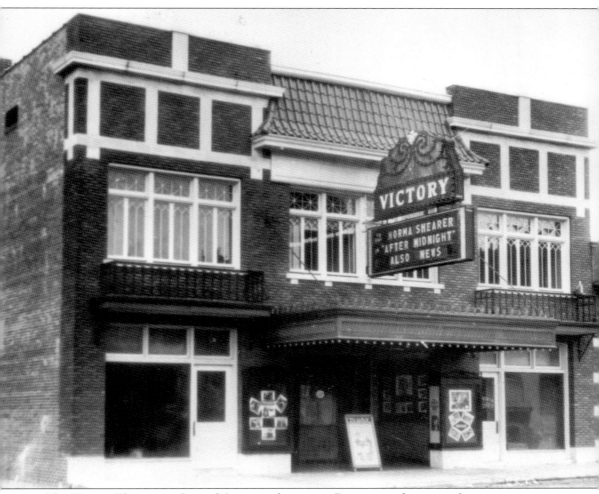

The Victory Theater on Second Street in downtown Rogers was the center for entertainment, showing its first film, *American Beauty*, in 1927. Many children growing up in Rogers saw their first Disney cartoon or Saturday afternoon cowboy show at the theater. Movies at that time opened with cartoons and newsreels before the main feature. The theater has gone through many changes and uses over the years. Restoration of this A. O. Clarke–designed building was led by the Rogers Little Theater along with many generous individual and corporate donations and grants. Luanne Diffin, Joe Rice, Joe Mills, John Ford, Jim Tull, and Jenny Harmon, with input from Gaye Bland of the Rogers Historical Museum, served as the design committee of the restoration. Dinner theater performances are now a regular part of the attraction of historic downtown. (Courtesy of the Rogers Historical Museum.)

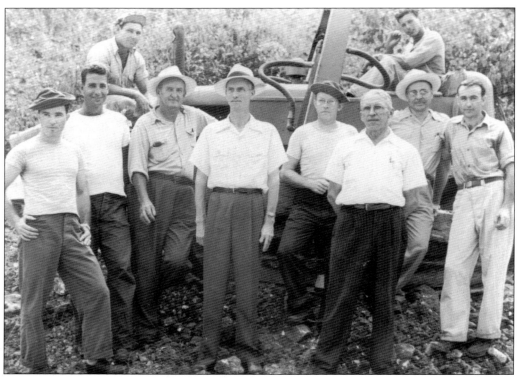

O. L. Gregory owned the 100-acre piece of land sold to the city in 1936 for Lake Atalanta. The lake was named for his wife and called "Lake Atlanta" by local people through the years. Huge blocks of limestone taken from the site were used to build the high sidewalks in downtown Rogers. Buddy Clark, "Fish Face" Lester, Dave Ogden, Frank Van Meter (?), Cactus Clark, Bob Vogt, Eddie Bautts, and Buck Clark participated in the groundbreaking. (Courtesy of the Rogers Historical Museum/Lavonne Clark.)

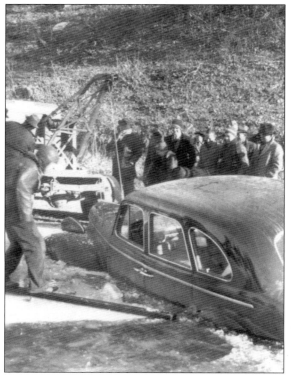

A long-remembered drama happened at the lake in January 1940. Lake Atalanta was frozen over, and C. Jimmie Carter with two friends, Ray Rogers and Buddy Whitlow, decided to ice skate in a car. They enjoyed sliding, braking, and spinning until the ice gave way and the fun was over—except for the many laughing spectators who urged on the rescuers with jokes and advice. (Courtesy of Sam Wood.)

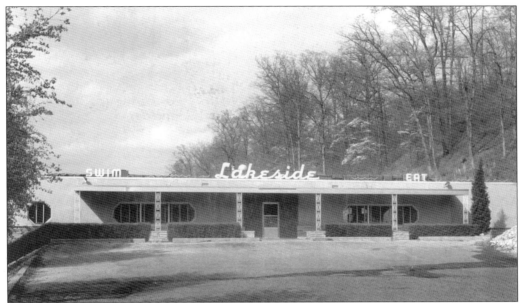

J. D. "Cactus" Clark and his wife, Lavonne, developed the recreational facilities at Lake Atalanta. The Lakeside Restaurant provided fine dining through the years. Family and high school reunions are often held there today. Many remember as children just walking through the restaurant, picking up a metal mesh basket to hold their regular clothes, pinning on a number to match the basket's number, and then walking out to the pool, slide, and high and low diving boards. In memory, the slide and high diving boards seemed to be higher and the water much deeper. You could look out over Lake Atalanta from the seating area around the pool. A wading pool for little children was at one end and the deep water at the other. "No running" was the only remembered rule. (Top image courtesy of Gary Townzen; Bottom image courtesy of the Lavonne Clark.)

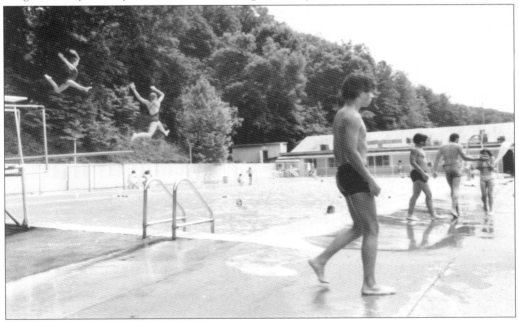

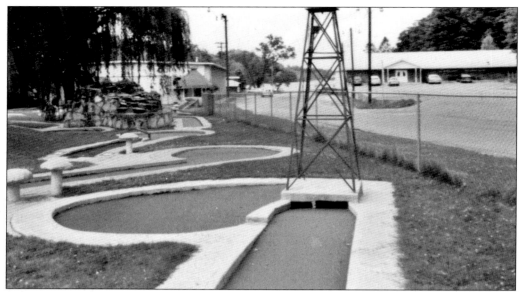

Lake Atalanta not only offered boats for rent on the lake, a restaurant, and swimming pool—the site also had a putt-putt golf course, skating rink, picnic tables, tennis courts, a creek to wade in, paddle boats, and ducks to feed. Easter sunrise services took place there as well as other holiday celebrations and family reunions. The skating rink was a favorite hangout for young people in the 1940s–1950s. You could rent your skates and stay until closing time. Loud music played and time was called for special couples skating. This got the smaller children off the floor for a while and let the high school couples have some time to themselves. A dirt road went around the lake and was a quiet place where couples sometimes gathered before going home. (Top image courtesy of Lavonne Clark; Bottom image courtesy of the Rogers Historical Museum.)

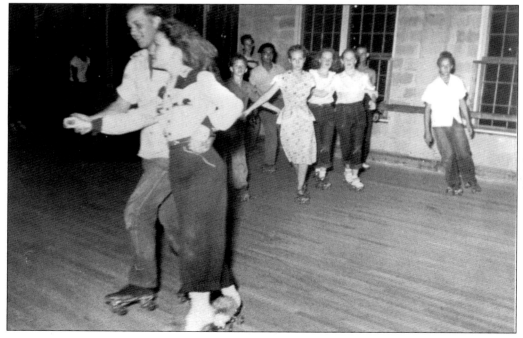

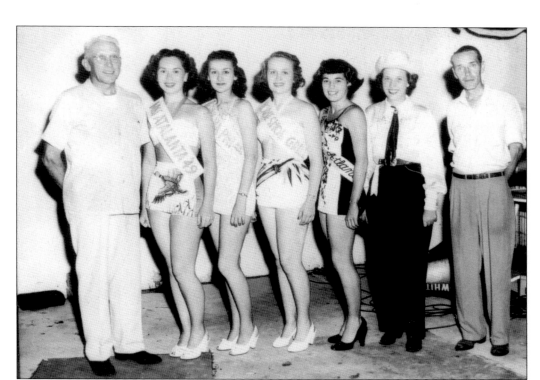

The 1949 Miss Atalanta Pageant was one of many such beauty contests through the years at the lake. Pictured from left to right are Bob Voght, Jo Woodruff, Anita Jones, Sandra McWhorter, Mary Perry, Patsy Locke, and an unidentified man. (Courtesy of the Rogers Historical Museum/Patsy Locke.)

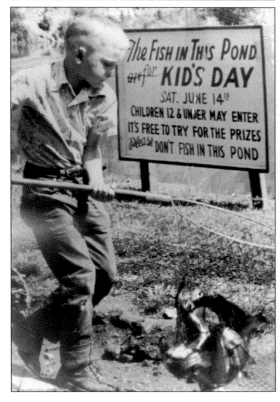

Older children and adults didn't monopolize all the fun at the lake. On a special Saturday in June, kids could prove their luck at fishing. This young boy has a heavy load of fish to help him compete for one of the prizes of the day. There was no entry cost in 1949 and any kid who could try his luck was assured of catching his share of fish. (Courtesy of the Rogers Historical Museum.)

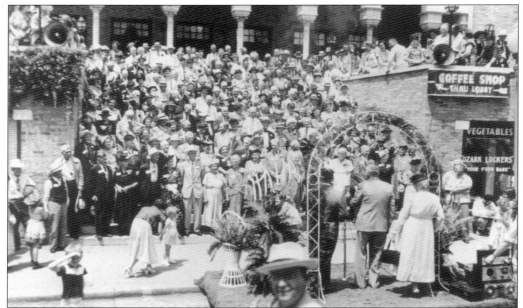

After World War II, the town yearned to return to normal. To celebrate life and love, 78 couples who had been married for 50 years dressed for the occasion and renewed their wedding vows in front of the Harris Hotel. Rev. J. H. Martin, former pastor of the Church of Christ, led this Golden Wedding Jubilee ceremony. Following the service, the festivities continued with a reception featuring a large cake furnished by the House of Webster. In keeping with the spirit of longevity, a parade including vintage cars wended through town, entertaining the onlookers and the wedding party. Band members provided the music and can be seen at upper right in these pictures. (Top image courtesy of the Rogers Historical Museum; Bottom image courtesy of Jim Strong.)

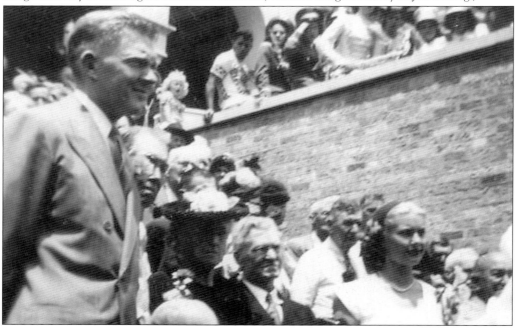

A big celebration welcomed spring and the first day of May. Children would fill May Day baskets with goodies and flowers, go to friends' houses, put a basket on the doorstep, ring the bell—then hide. Supposedly the baskets were a surprise and the giver remained a mystery. Young girls danced as May Day fairies (above) and older girls (below) dressed in long skirts danced around the maypole, weaving in and out, lacing the poles with their ribbons. May Day fairies included in this picture are Nancy Laney, Carolyn Finn, Jeanette Ball, Jeanie Wilson, Aurita Strong, Merry Jane Kilman, Marilyn Dean, ? Creech, Carolyn McElroy, Dell Christy, Betsy Bronsen, Betsy Robinson, Wanda Downum, Norma Jean Miller, Connie May Best, Harriet Sue Howland, Rosemary Jones, Carolyn Shaddox, Sue Fraiser, Mary Jane Herndon, Janice Sue Lane, Margaret Ann Holyfield, Lois Faye Lions, Sue Landers, ? Carter, Donna Cunningham, Marcella Thompson, Barbara Brust, and Elaine Daughtery. (Courtesy of Jim Strong.)

Cub Scout Pack 25 collected newspapers in 1944 to help support the war effort. They didn't have a car to pull the trailer, so the boys pushed one—made in the high school shop—all over town picking up newspapers. It was a hard pull uphill. When loaded, it took everyone to keep the trailer from getting away from them on the downhill. The pack was sponsored by Central Ward Elementary School PTA and the Methodist church. Shown in the picture are, from left to right, (first row) John Miller, Lanny Conley, Dickey Adcock, John Holyfield, Wayne Bennett, Harold Webster, Russell Riggs, L. E. Perry, Lee Moore, Guy Cable, Jackie Baggett, Clayton Barron, and Bobby Scott; (standing and on top of trailer) Davis Duty, Tommy Carrol, D. Pettit, John Hawkins, Billy Strong, Billy Garrett, Jimmy Strong, Sonny (Howard) Wilks, Jimmy Pandle, Edward Hale, Joe Randle, Steve Pierce, John White Duty, Sonny Kirby, Cliff Stevenson, and Rev. Jimmy Randle. (Courtesy of Jim Strong.)

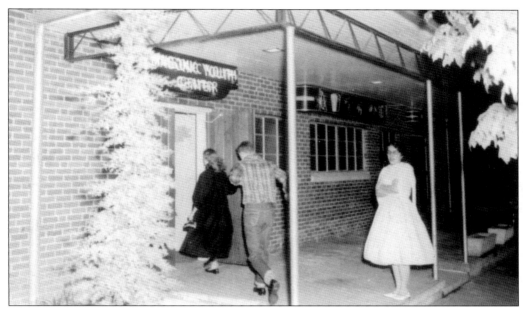

Many civic organizations flourished in Rogers, providing community support and a place of fellowship for their members. The Masonic Lodge was one of the earliest, organizing in 1887. High school students remember dances and parties after football games held at the Masonic Youth Center on Poplar and Third Streets, where city administration offices were located for many years. Masonic meetings for Masons, Eastern Star, DeMolays, and Rainbow Girls were held at the lodge. (Courtesy of the Rogers Historical Museum/Casey Ward.)

A favorite hangout for high-school students in the 1950s was Jack's Drive In on Eighth Street. A miniature jukebox listing records to play for a nickel sat on each table. You could punch in your music on the Select-o and the record would drop in place on the big jukebox and play the song. Jack's specialized in hamburgers and Cokes and provided a fun stop on the way home from a ballgame or party. (Courtesy of the Rogers Historical Museum/Casey Ward.)

In 1947, Dorothy Larimore and Louise Jefferson organized the first Wing Scout troop in Arkansas at the Rogers Airport. The group was sponsored by the Rogers Women's National Aeronautical Association. A style show of old-time fashions still looks glamorous on the girls of this 1951 Wing I Scout Group. (Courtesy of the Rogers Historical Museum.)

During the town's centennial celebration, women wore dresses of the period with matching hats or bonnets. Men were required to wear beards or be "arrested." The 100-foot-long cake made for this special anniversary became more of a problem than a treat when it had to be rushed indoors to avoid the rain. (Courtesy of Opal Beck.)

Seven

PRESERVING
OUR HERITAGE

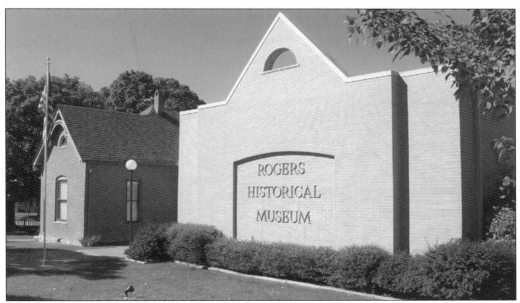

Opal Beck, Rogers City Councilwoman, suggested organizing a museum as a way to celebrate the nation's bicentennial. Vera Key led the effort, and the museum opened in 1975 in the former First National Bank building on First Street. The museum moved into the Second Street 1895 Hawkins House in 1982. The Key Wing opened in 1987, adding more exhibit space, offices, and a research room. The museum, led by director Dr. Gaye Bland and staff, opened many major exhibits during the years including: "The Sagers: Pioneer Cabinetmakers," "Buried Dreams: 'Coin' Harvey & Monte Ne," and "The Van Winkle Legacy." The former post office is now used as the Museum Education Annex with lively and interactive programs offered year-round for children. (Courtesy of the Rogers Historical Museum.)

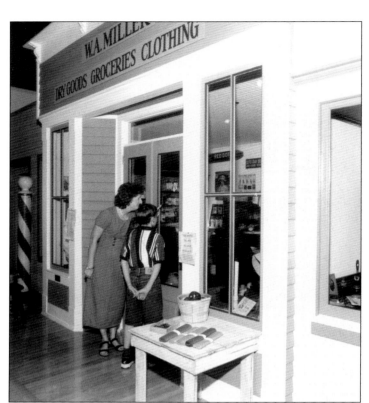

One of the favorite tours in the Vera Key Wing in the Rogers Historical Museum offers a "real life" experience on First Street in Rogers during the 1880s (top image). Children can peer in the windows or play checkers in front of this facsimile of W. A. Miller's store selling "Dry Goods—Groceries—Clothes." A red-white-and-blue barber pole of the time advertises the business next door. The typical false-front buildings (bottom image) were the basis for the display design. The "walk" down First Street depicted in the display helps visitors to understand how life was lived during this period. (Courtesy of the Rogers Historical Museum.)

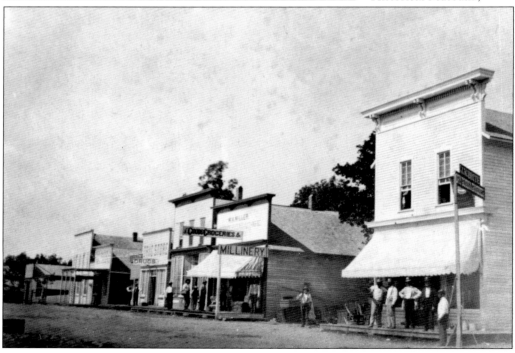

Marianne Woods became the first professionally trained museum director in Rogers. Here she explains the "weasel" to school-age children. The weasel was used to measure yarn that had been made on the spinning wheel. This exhibit was part of the Hawkins House tour before the Key Wing opened in the late 1980s. (Courtesy of the Rogers Historical Museum.)

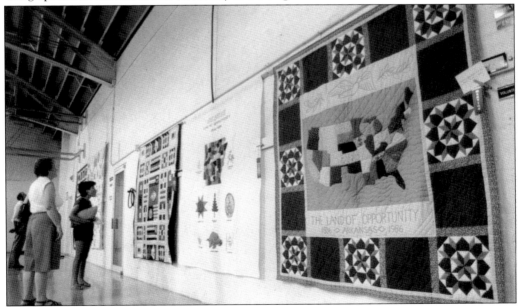

Over three dozen period quilts are in the Rogers Historical Museum collection. This exhibit of antique quilts was part of a special display in the 1990s funded by the National Endowment for the Humanities. Quilts were hung at the Rogers Armory on Eighth Street, currently the Boys and Girls Club. (Courtesy of the Rogers Historical Museum.)

Children like to try a crank telephone or use a typewriter in the museum "Attic"—a major contrast in technology from today's cell phone and laptop computer. A treadle sewing machine can be seen in the background, used to make dresses similar to the one on display. (Courtesy of the Rogers Historical Museum.)

Playing dress-up in period clothes from the "Attic" reminds visitors of long-ago days at grandmother's house. Antique toys, a cash register, kitchen utensils, and other useful gadgets from years past help children understand history in a hands-on way. (Courtesy of the Rogers Historical Museum.)

"We Did What Had to Be Done" honored the men and women who served in World War II. Dr. Gaye Bland, museum director, sits in a chair from a typical home of the time. Excerpts from a radio broadcast played music and gave news of the day. Visitors could browse through a scrapbook with 1940s pictures or look in two activity boxes including how-to tips on spotting enemy planes or using ration stamps. (Courtesy of Marilyn Collins.)

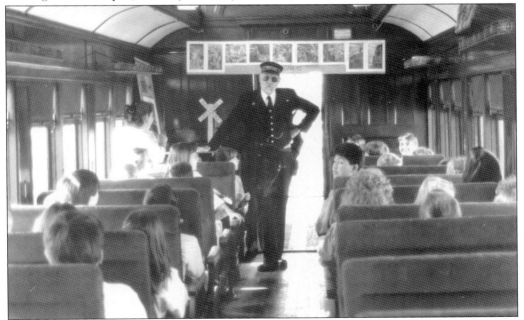

Educational programs sponsored by the Rogers Historical Museum increased dramatically in the early 1990s. A train ride for all fifth graders in Rogers's schools was one of these special programs. The conductor brought history to life as 1,225 children took turns riding the train on short trips. (Courtesy of the Rogers Historical Museum.)

Many buildings in downtown Rogers had fallen into disrepair by the late 1970s to mid-1980s. Jenny Harmon was the director of Main Street Rogers from 1985 to 1999. During this time—with assistance from the City of Rogers, individual merchants, and a series of grants—First Street Plaza restoration and construction of Frisco Park became a reality. (Courtesy of Main Street Rogers.)

As part of the Rogers Centennial Celebration in 1981, the Frisco railroad donated this caboose for Frisco Park. Rogers Iron and Metal lifted the caboose from the tracks to the park—no easy feat. The caboose is managed by the Rogers Historical Museum and is open to the public, May through October, during museum hours. (Courtesy of the Rogers Historical Museum/Opal Beck.)

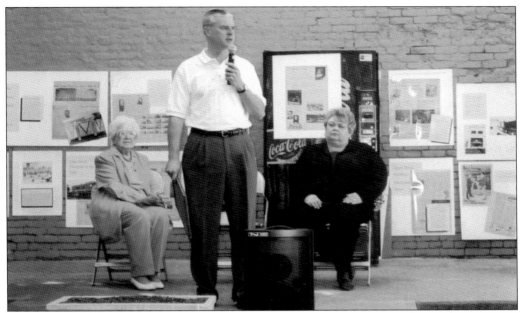

"The Downtown Is Uptown" presented a "Salute to Downtown Merchants" for the 120th anniversary of Rogers. Program presenters were, from left to right, Opal Beck, Mayor Steve Womack, and Jan Oftedahl. The event was held appropriately in Centennial Park on First Street. Early newspaper clippings and other historic memorabilia from downtown are on the wall behind the speakers. (Courtesy of Marilyn Collins.)

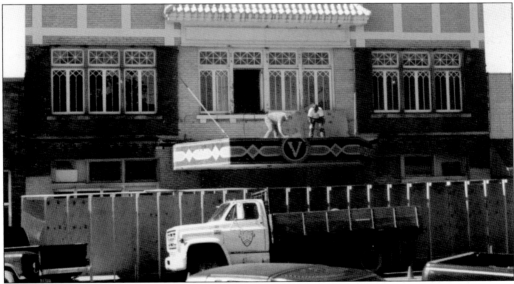

A 10-year fund-raising effort by the Rogers Little Theater group purchased the old Victory Theater on Second Street. With private and corporate donations, the theater is now restored to its former splendor. Well-produced and beautifully performed dinner theater and afternoon matinees delight audiences. John Mack of Perry Butcher and Associates was project coordinator. Many dedicated volunteers and local business owners contributed to the overall success of this project. (Courtesy of Marilyn Collins.)

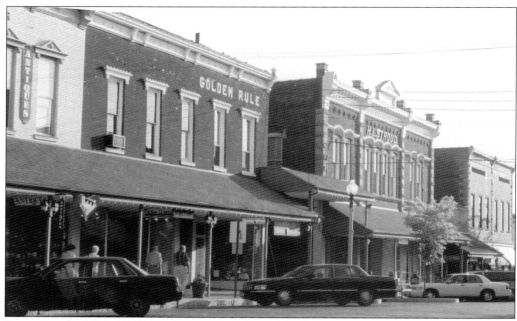

Downtown buildings, brick streets, and high limestone curbs are much the same today as in the early days of Rogers. Walnut Street leads into downtown Rogers from Interstate 540, or visitors can turn east from Highway 71 Business (Eighth Street). One can still see the Stroud's and Golden Rule business names on the buildings. Most noticeable of architectural features in downtown buildings is the dentil molding along the top facades, providing an interesting play of light and shadow changing with the direction of the sun. The limestone quoin blocks down the sides of buildings and above the windows are also quite distinctive. This view is shown from First Street facing down Walnut Street toward Second Street. (Courtesy of Marilyn Collins.)

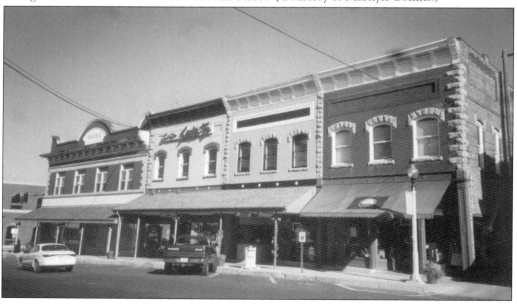

The Frisco Festival, sponsored by Main Street Rogers, is a two-day event held in downtown Rogers. Activities for children and adults, sponsored by local organizations and businesses, offer a large selection of food, rock-wall climbs, dunking of local dignitaries, and car shows, plus live entertainment. The Rogers Historical Museum sponsored this old-time jug band (below) from Maysville, Arkansas, playing on a variety of makeshift instruments. (Top image courtesy of Lewis Brewer; Bottom image courtesy of the Rogers Historical Museum.)

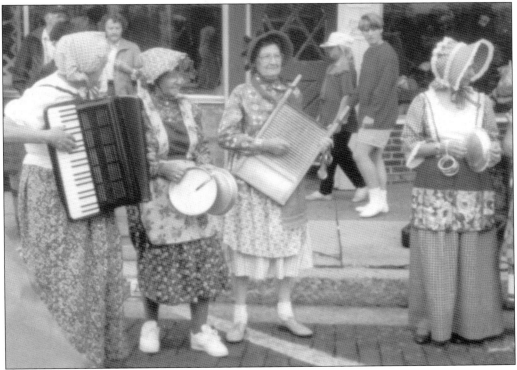

Daisy Air Gun Museum preserves the history of air guns from the 16th century to those made by Daisy Manufacturing today. The museum, originally located in the former First National Bank building on First Street, is now housed in the Juhre Building on the corner of Walnut and Second Streets. Cass Hough, World War II veteran and executive vice president of Daisy at the time, introduced this poster of the American Boy. The original poster included "The American Boy's Bill of Rights." (Courtesy of the Daisy Air Gun Museum.)

This "On Top of the World" poster commemorated Daisy's 75th anniversary. The poster appeared on the cover of their anniversary catalog. The cover read in part, "With infinite faith in boys who make men who make America . . . we look to the future through youthful eyes. While proud of our past 75 years, we're more eager to engage the challenges of the next 75." (Courtesy of the Daisy Air Gun Museum.)

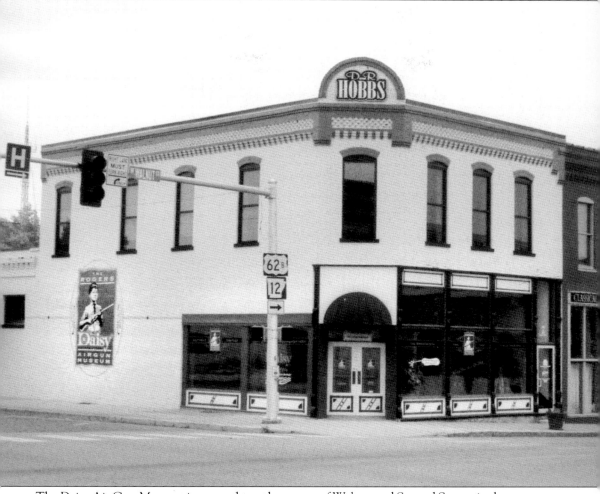

The Daisy Air Gun Museum is currently on the corner of Walnut and Second Streets in downtown Rogers. Air guns from the 16th century are on display in the museum as well as every air gun sold by Daisy. These names are familiar to anyone ever owning an air gun—Red Ryder, Buck Jones, Buzz Barton, and Buck Rogers. Other Daisy toys are also exhibited, and this is the only place where you can purchase the entire Daisy line. A certificate of authenticity is given with every purchase including the history of the model. The buyer's name, series number of the gun, date of purchase, and other information is kept on file in the museum. (Courtesy of Marilyn Collins.)

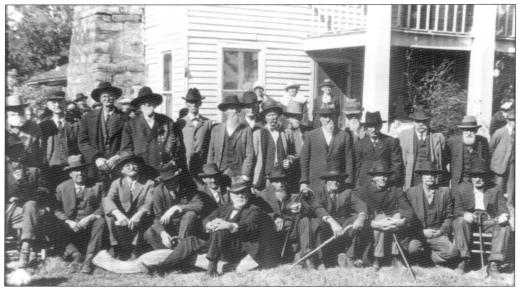

Rogers is proud of those who served or died in the military serving this nation. The following are efforts to honor those fallen heroes. Veterans of the Battle of Pea Ridge met for separate reunions in the years following the Civil War. Many participants came from outside the local area. By the late 1800s, soldiers started holding joint reunions. The photograph above shows the last reunion in 1926, held on the battleground at Elkhorn Tavern. (Courtesy of the Rogers Historical Museum.)

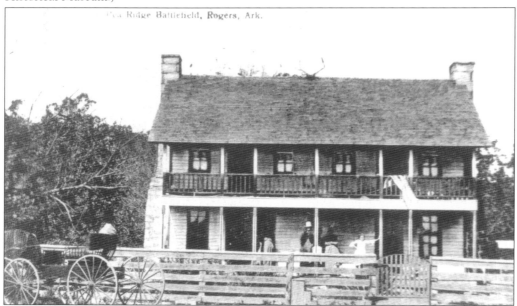

Pea Ridge Battlefield, Rogers, Ark.

The Battle of Pea Ridge was the most important battle west of the Mississippi River. The river provided a conduit for men and supplies for the Confederate army. The battle raged for two days, March 7 and 8, 1862, with the advantage going from side to side. Over 1,000 men were lost by each side with the final outcome going to the Union. Elkhorn Tavern was used as a hospital during the battle. (Courtesy of the Rogers Historical Museum.)

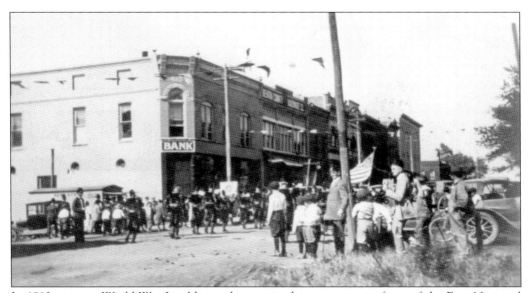

In 1910, prior to World War I, soldiers take part in this ceremony in front of the First National Bank on Elm Street. Standing at attention, they salute the flag. The American Legion Post in Rogers is named in honor of William Minter Batjer, the first soldier from Rogers to die in that war. (Courtesy of Duane Hand.)

The local National Guard was called up to train in Fort Sill, Oklahoma, before America's entrance into World War II. They were allowed to come home from training on Armistice Day, November 1, 1941, to help celebrate the dedication of the Rogers Armory on Eighth Street. Following the war, Boy Scout Troop 109 and the Rogers Rotary Club placed a granite stone on the armory grounds that read: "Spruce and maple trees planted February 8, 1949, in memory of our boys who made the supreme sacrifice in World War II." (Courtesy of the Rogers Historical Museum.)

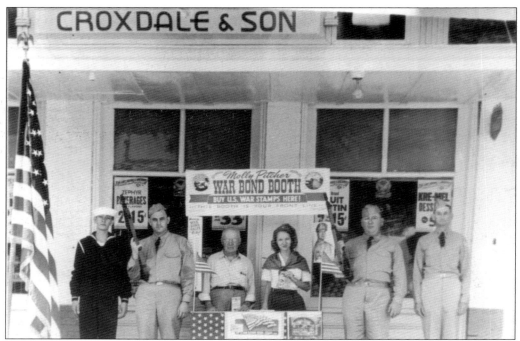

Recruiting booths for World War II were set up in town as well as at this booth selling war bonds in front of the Croxdale and Son business. Representatives of the armed services encouraged people to "Buy U.S. War Stamps Here!" Jim Croxdale is second from the right. (Courtesy of the Rogers Historical Museum/Ruth Wright.)

World War II veterans recounted their experiences to visitors during the museum's World War II exhibit. A quilt with names of soldiers embroidered was displayed. Dr. Gaye Bland, museum director, stands in front of another part of the exhibit depicting the war. How the homefront was affected by the war was part of the display. (Courtesy of Marilyn Collins.)

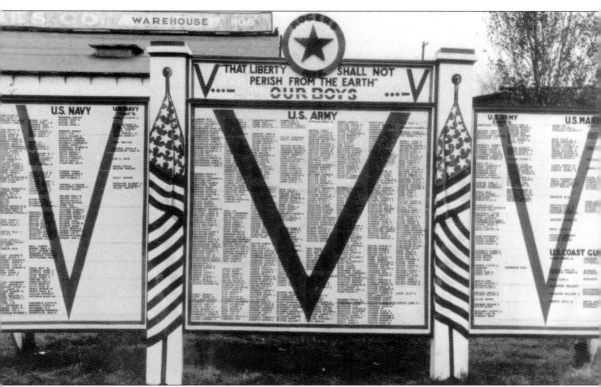

During World War II, the local community put up this sign at Frisco Park listing the names by service branch of "Our Boys." These were the people who served in the war from Rogers. If a service person died, a gold star was placed by his or her name. The sign read, "That Liberty Shall Not Perish From the Earth." (Courtesy of the Rogers Historical Museum.)

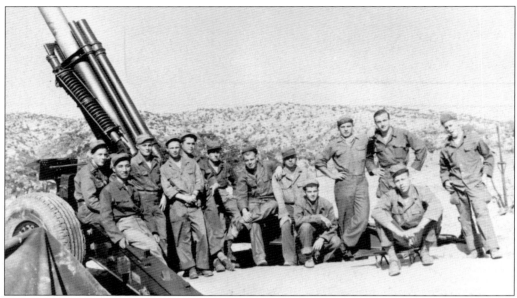

Once again, the country called soldiers to conflict overseas. This time Battery F, 142nd Field Artillery reorganized into Battery C, 936th Field Artillery Battalion and headed for Korea. Pictured above from left to right are Earl Ray Stephenson, a Korean boy, Dale Bland, Rex Watkins, Ralph "Buck" Harris, J. D. Grimes, Wayne Heighton, Rogers Morris, Carl Cotrill, Edward Cherry, Ray "Dog" Daugherty, Cleo Kirk, and Mark W. Dockendorf. The troops returned home in 1952 without two Benton County men lost in battle. Capt. Douglas E. Morrow was from Rogers. (Courtesy of the Rogers Historical Museum/Finnis Dale Richards.)

The conflict in Vietnam began shortly after the Korean War, but the National Guard from Rogers was not activated as a group; however, individuals from Rogers did serve. A group of town citizens, corporations, and organizations placed this plaque at the Rogers airport in honor of the sacrifice of all those who served in Vietnam. (Courtesy of Marilyn Collins.)

A wreath was placed in front of city hall after September 11, 2001, to honor the heroism of the police and firefighters who worked—and those who died—to save as many people as possible from these terrorist attacks. It will be the role of future books to tell of memorials for the fallen men and women in Iraq and Afghanistan. (Courtesy of Marilyn Collins.)

ACROSS AMERICA, PEOPLE ARE DISCOVERING SOMETHING WONDERFUL. *THEIR HERITAGE.*

Arcadia Publishing is the leading local history publisher in the United States. With more than 3,000 titles in print and hundreds of new titles released every year, Arcadia has extensive specialized experience chronicling the history of communities and celebrating America's hidden stories, bringing to life the people, places, and events from the past. To discover the history of other communities across the nation, please visit:

www.arcadiapublishing.com

Customized search tools allow you to find regional history books about the town where you grew up, the cities where your friends and family live, the town where your parents met, or even that retirement spot you've been dreaming about.